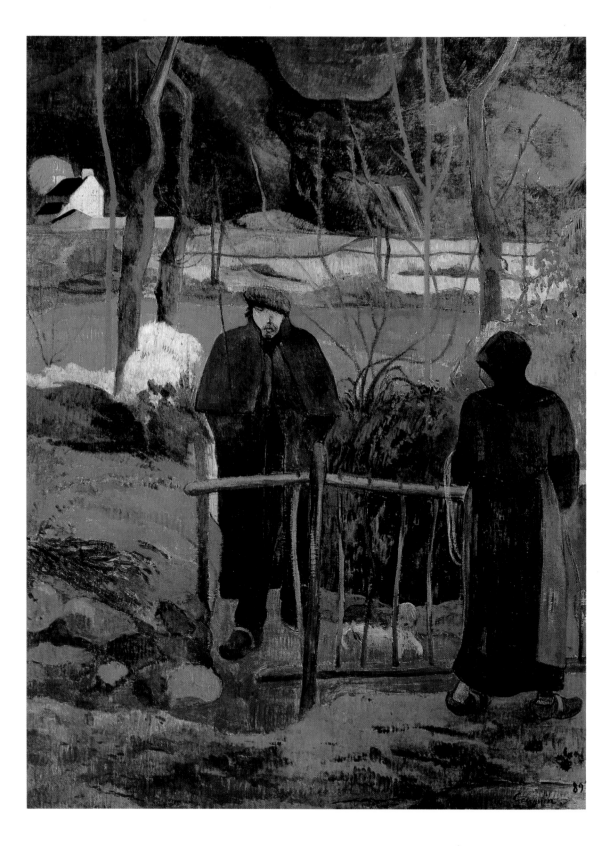

Ingo F. Walther

PAUL GAUGUIN

1848–1903

The Primitive Sophisticate

TASCHEN

KÖLN LONDON LOS ANGELES MADRID PARIS TOKYO

FRONT COVER:
Detail from: **When Will You Marry?** (Nafea Faa Ipoipo?), 1892
Oil on canvas, 101.5 x 77.5 cm
Rudolf Staechlin Collection,
Kunstmuseum Basel, Basle

ILLUSTRATION PAGE 2:
Bonjour, Monsieur Gauguin, 1889
Oil on canvas, 113 x 92 cm
Národní Gallery, Prague

BACK COVER:
Detail from: **Caricature Self-Portrait**, 1889
Oil on wood, 79.2 x 51.3 cm
National Gallery of Art, Washington

© 2000 Benedikt Taschen Verlag GmbH
Hohenzollernring 53, D–50672 Köln
www.taschen.com
English translation: Michael Hulse
Cover: Catinka Keul, Angelika Taschen, Cologne

Printed in Germany
ISBN 3–8228–5986–9

Contents

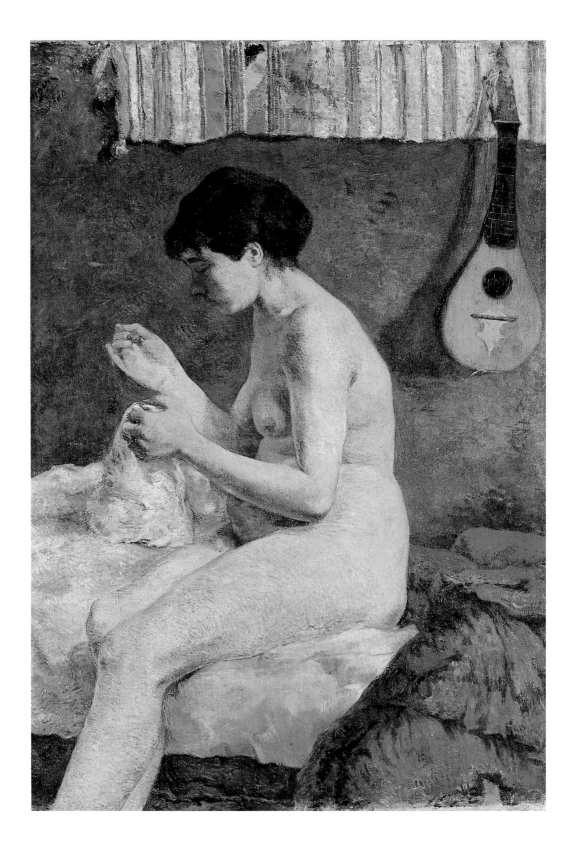

The Age of Impressionism
1848–1887

There cannot have been many other artists who set out as wholeheartedly to live the life they envisioned in their art as Paul Gauguin did. He lived between two worlds. In this art he held up a mirror to his own civilization, which he despised, and showed an alternative, primitive life in all its simple, naïve harmony. But painting it was not enough for Gauguin. He wanted to experience it himself. He wanted to prove that South Sea exoticism was not merely a forced and magical escapism, of the kind that was fascinating his European contemporaries in an age of world fairs and newspaper reports. Gauguin personified a new union of art and life, imagination and order, and in anticipating this predominant 20th century characteristic he became one of the true pioneers of modernism.

Gauguin discovered his artistic bent relatively late. When he made his break with comfortable middle-class life, he already had a wife, a family, and a small fortune. In making the break he liked to see himself as an unconventional anti-hero, forging ahead on his own, indifferent to the recognition of his fellow-men. But much as he would have liked to despise the *bourgeois* world, Gauguin the outsider still hankered after the success which Gauguin the stock market speculator had formerly achieved. As his failure became ever deeper, he became a wrathful critic of that European civilization which ignored him, and in the end even took to actively resisting the colonial administration in Tahiti.

Gauguin's artistic models were Giotto, Raphael and Ingres, and the literary tradition he valued was that of Montaigne and Rousseau, who had considered the circumstances of the colonial peoples and gone on to accuse their own civilization of thinking too highly of itself and indeed of being megalomaniac. The "noble savage" was the better human being because he was more contented and dwelt at peace with Nature. And that automatically meant he led a happier life. It was that happiness that Gauguin was seeking.

Gauguin's dreams of escape, though resigned and melancholy, were not without an element of shrewd calculation. He shared his longing for a distant paradise with the whole of high society. When he sprang his exotic pictures on an unsuspecting public, he was not only showing the sources of his inspiration: he was also indicating the sources of his income. Rolling up his canvases and sending them in

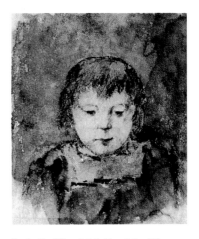

Portrait of Gauguin's Daughter Aline, ca. 1879/80
Watercolour, 18.6 × 16.2 cm
Private collection, Basle

Study of a Nude. Suzanne Sewing, 1880
Oil on canvas, 115 × 80 cm
Ny Carlsberg Glyptotek, Copenhagen

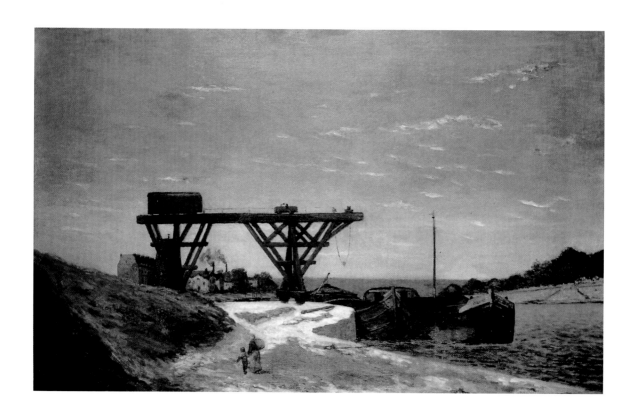

The Seine in Paris between the Pont d'Iéna and the Pont de Grenelle, 1875
Oil on canvas, 81 × 116 cm
Private collection

secure packages from Tahiti to France, to adorn the walls of European salons, he was no less the *bourgeois* than when he urged his son to take to a useful career, such as that of engineer, rather than the penury of an artist's life. "He is a tremendous businessman, or at least he thinks like one," Camille Pissarro once said. And at heart Gauguin remained a businessman his whole life long. Whatever his intentions, he had been subjected to the same education as his contemporaries, conditioned to compete and to uphold the norms and orderly values which were sincerely believed to be for the best, and which damned him to failure the moment he began. Just as nations sought out peoples they could subjugate and colonize, so Gauguin needed conquests, for his own sake and for his art.

In November 1873, aged twenty-five, Gauguin married a young Danish woman called Mette Sophie Gad in Paris. He had travelled far and wide as a sailor. She was a children's nanny. Longing for security (on his side) and a fascination with travellers' tales (on hers) had brought them together, but the marriage was flimsy and did not survive Gauguin's discovery of his artistic talent. Though he and Mette did not divorce, they duly went their separate ways.

But at first their household flourished. The young wife could afford major purchases because Gauguin was earning good money at the stock exchange. They had five children — Emile, Aline, Clovis, Jean René and Pola — and doted on them all. The doors of Parisian high society were presently opened to them, and Gauguin — behaving as

his social standing required — began to collect Impressionist paintings. It was not very long before he took up painting himself, as a hobby. He studied the old masters in the Louvre together with another painter, Claude Emile Schuffenecker. In his own unambitious works he chose to depict scenes of family life.

The Seine in Paris between the Pont d'léna and the Pont de Grenelle (p. 8) is one of the earliest paintings in which Gauguin abandons the subject of idyllic family life. It is a tranquil and atmospheric Sunday scene. No one is working, and the crane which dominates the picture seems forlorn. The sky is peaceful and blue, the two figures in the foreground are doing nothing to disturb the sense of quiet, and the very barges and houses look sleepy! In this painting we see Gauguin toying with Impressionism, albeit tentatively. Impressionism was the major art movement of his time, and its hallmark was unemotional scrutiny of a busy, lively world. Gauguin, by contrast, appears to be fixing his attention on lack of emotion itself. Impressionism liked to set its images adrift in a shimmering sea of light. Gauguin, by contrast, highlights a personal love of static detail. The mood of the painting remains cool, and the painter himself distant.

Consistently enough, when Gauguin came to exhibit one of his paintings for the first time it was not alongside the Impressionists but

Aubé the Sculptor and His Son, 1882
Pastel, 53 × 72 cm
Musée du Petit Palais, Paris

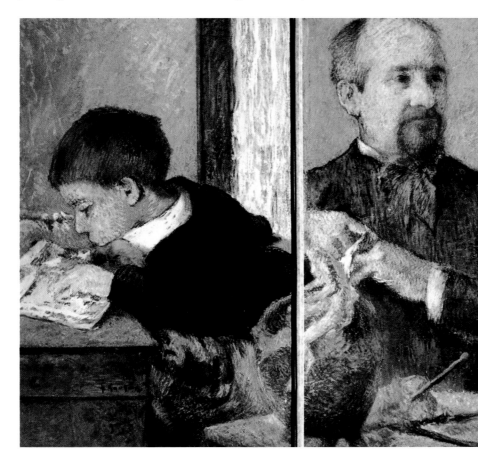

Study for The Bathers, 1886
Black chalk and pastel, 57.3 × 34.7 cm
Art Institute of Chicago, Chicago

at the official *Salon*. The *Salon* was notorious for its conservatism amongst the group of young artists led by Edouard Manet und Claude Monet. Only three years later, though, at Pissarro's lively encouragement, Gauguin did exhibit with the Impressionists. There he encountered that rejection of traditional middle-class notions of art which he was to espouse time and again in the years ahead. Gauguin continued to work at the stock exchange. But the provocative and novel stance adopted by the Impressionists sharpened his own critical faculty. And he became a success, showing seven canvases at the annual Impressionist exhibition in 1880.

Study of a Nude. Suzanne Sewing (p. 6) is a thoroughly Impressionist work in its use of dynamic light effects produced by innumerable thin brushstrokes. The writer and art critic Joris Kar Huysmans, a contemporary of Gauguin, spoke of the "little creases below the bosom, which is highlighted by dark patches and seems to be doing some wild dance". It is as if a nervous, colourful element had been introduced into a wholly static subject, a subject which hardly seems Impressionist in character at all. The naked woman seated at her work possesses a quiet dignity that awakens no shameful responses, and the way in which Gauguin has perceived her anticipates his later attempts to capture the calm but powerful presence of the South Sea peoples. It is true that Gauguin made use of Impressionist methods. But he did not share their view of the world, or their emphasis on dynamic flux.

In November 1882 a stock market crash put an abrupt stop to Gauguin's double life as broker and artist. The crash cost him and his friend Schuffenecker their jobs. And it left Gauguin free to indulge in the wayward life of a dandy to his heart's content. He had always longed for the bohemian existence that suddenly became available to him; but the snag was that now he had a family to care for, five children to feed, and a house. None of this fitted in with the image of a drop-out adrift in the big city. As if to prove that artists *could* be responsible family men, he painted his double portrait of *Aubé the Sculptor and His Son* (p. 9) the very same year. The boy who is naturally destined to follow in his father's footsteps and is drawing on a sketch-pad, and the artist wholly absorbed in this work, together show that a cosy family idyll and independent creative labour are compatible. But Gauguin was no sculptor. Nor was he an Aubé.

At any rate, Mette, unable to share her husband's euphoric view of art, went to stay with her parents in Denmark. Gauguin felt obliged to look for another remunerative job, but his quest was half-hearted, the economic climate poor, and so he was unsuccessful. For a while he worked as a sales representative for a French textiles firm, in his wife's home town, Copenhagen. But all he got out of his northern venture was an exhibition of his paintings, and it was a disaster. "I deeply loathe Denmark, and the Danish people, and the Danish climate," he wrote, and soon returned to Paris. His family, which saw him as a ne'er-do-well, stayed behind, though Gauguin was accompanied by his son Clovis and had to provide for him out of his income as an artist.

Cattle Drinking, 1885
Oil on canvas, 81 × 65 cm
Galleria d'Arte Moderna, Milan

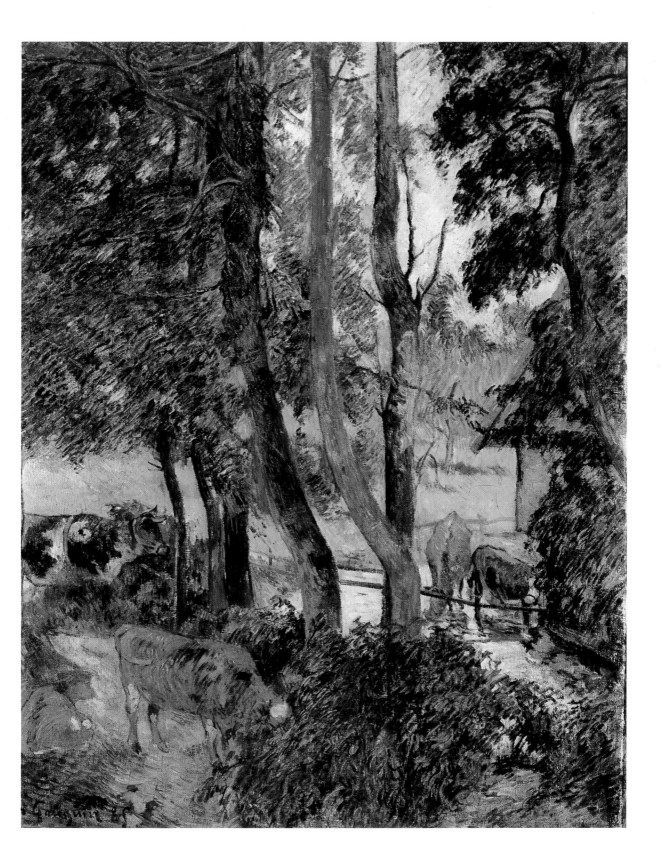

The Four Breton Girls, ca. 1886
Oil on canvas, 72 × 91 cm
Neue Pinakothek, Munich

"When the lad had his attack of smallpox I had just twenty centimes in my pocket," Gauguin wrote to his wife from the depths of the Parisian winter. His tone was resigned, but also betrayed the spiteful condescension of the misunderstood genius who blamed others for his own misfortunes. He had not sold a single painting, and was earning a miserable five francs a day pasting up posters. He had longed to drop out of his *bourgeois* career, but when the time came the move was unplanned and proved unsuccessful. Escape into the bohemia of dandies, pleasure-seekers and self-proclaimed artists had cost him dearly. When his flight into the city's sub-culture had turned out to be a failure, Gauguin contemplated retreat to the country.

In summer 1886 Gauguin moved to the little village of Pont-Aven on the Atlantic coast of Brittany, "where you can live on next to nothing". He had sent his son Clovis back to Denmark, to his mother – indeed, to put it baldly, he had got rid of the boy. By now it was not only a middle-class career that seemed beyond his powers; he even felt unequal to being a father. He compensated by plunging all the more energetically into his artistic labours. At Madame Gloanec's boarding

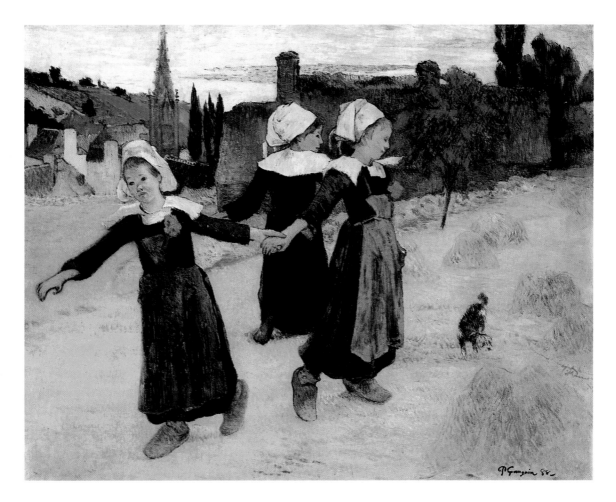

Breton Girls Dancing, Pont-Aven, 1888
Oil on canvas, 73 × 92.7 cm
National Gallery of Art, Washington

house he attracted like-minded young artists who were tempted by the region's spartan beauty and an inexpensive life. Now he could at least write to Mette that he enjoyed recognition as a painter: "I am working well here and successfully. They respect me as the best painter in Pont-Aven. Respect won't earn me a single centime, true. But my reputation is excellent, at any rate, and everyone wants my advice." Gauguin was still very poor, but at least he was increasingly confident.

In *The Four Breton Girls* (p. 12) we see him relying wholly on a quality of monumental simplicity in his subject. Folk costumes and dance show his interest in the uncomplicated rustic life of Brittany, while the painting's colourfulness still owes a good deal to the shimmering effects of Impressionism. What is newly important in this work is a sense of static equilibrium and poise, conveying such calm that the movements of the dance seem arrested. In his future work, Gauguin was to emphasize major form, and firm, upright lines that define shape and contour were to be its characteristic hallmark. The silhouetted faces of three of the women already bear traces of this.

In 1886, Gauguin exhibited no fewer than nineteen paintings at the Impressionists' salon. This was ironical. While Monet was painting the

glittering diversity of city life, Gauguin had gone in the opposite direction, in search of tranquillity. Furthermore, Gauguin was upstaged at the salon by Georges Seurat, who exhibited his massive *Sunday Afternoon at the Ile de la Grande Jatte.* In this work, Seurat underpinned Impressionist approaches with theoretical principles of perception. Both Seurat and Gauguin were questing for major, inviolable form, in their different ways, but Seurat was using the refined means of civilization in his attempt, while Gauguin was impelled to look elsewhere, hoping to find what he sought in primitivism.

After Brittany, Gauguin intended to escape for good by making for the unspoilt simplicity of the tropics. None too sure of his plans, he decided to start in Panama, where the building of the Canal promised a livelihood. A friend called Charles Laval, one of the Pont-Aven painters, accompanied him. As so often, however, Gauguin's skills were unwanted in Central America too, and the two friends, somewhat rudely awakened, moved on to the French island colony of Martinique in the Caribbean.

At the Pond (p. 15) was painted there. Gauguin's feel for the brightness of colours had a new sensitivity, and the picture finds him continuing his efforts to use Impressionist methods of applying paint when tackling motifs of some dignity. Here once again the most important elements in the composition — the trees on the centre axis, the animals — were highlighted, marked out against the colourful confusion of bright lines that remains predominant. And at last Gau-

Breton Girls Dancing, 1888
Pastel on paper, 24.2 × 41 cm
Rijksmuseum Vincent van Gogh, Amsterdam

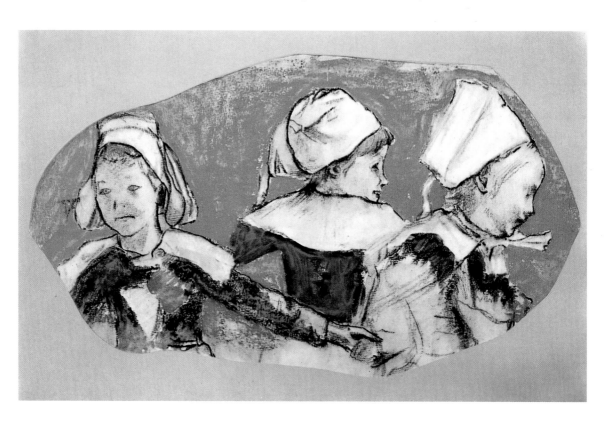

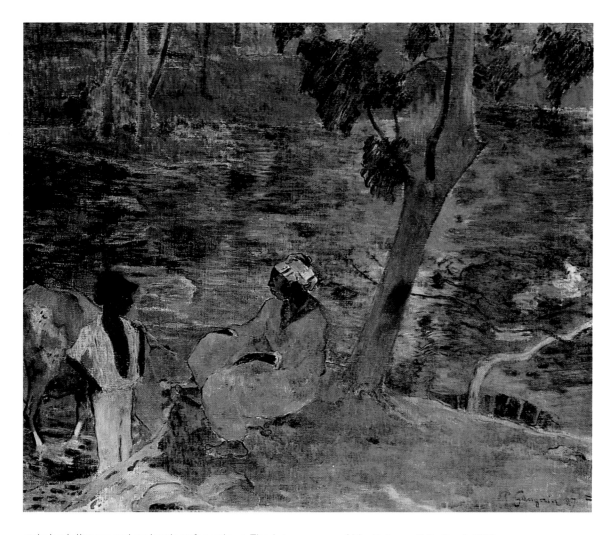

At the Pond, 1887
Oil on canvas, 54 × 65 cm
Rijksmuseum Vincent van Gogh, Amsterdam

guin had discovered an instinct for colour. The intense sun of Martinique gave him a sense of the resplendent brightness of colour which Brittany could never have offered him.

Gauguin's love of the tropics may have been an escapist flight from civilization, but it was also an attempt to rediscover the happiness of his South American childhood.

Born in Paris, Paul Gauguin had gone to Peru with his family at the tender age of one. His parents had strong republican convictions and when Louis Napoléon returned to France they quit the country. Peru was the home of Gauguin's grandfather, a hundred-year-old survivor with the evocative name Don Pio Tristan Orosco, and doubtless the old man made an unforgettable impression on the infant Paul. At all events, Paul Gauguin was fascinated by everything exotic from his childhood on. Though his family returned to France in 1855, Gauguin betrayed a hankering for foreign parts in his youth, and went to sea as a sailor. In a sense, his settled years of *bourgeois* life from 1872 to 1882 were merely an interval of quiet along his restless way.

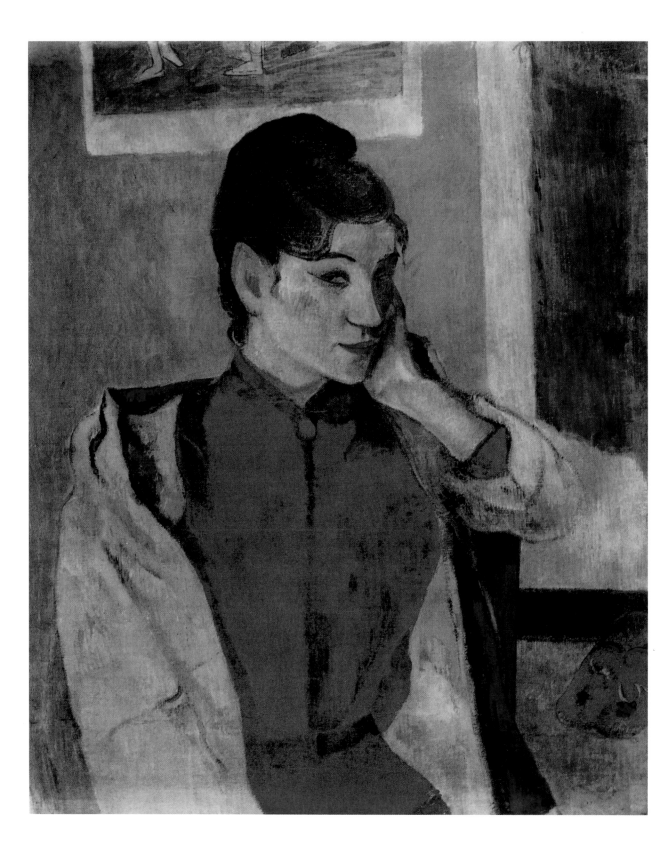

Suggestion and Expression
1888–1891

The year 1888, when he returned to France, was to see Gauguin's most decisive artistic progress. As he himself attested: "This year I have sacrificed everything, all my technique, all my colour, to style." Finally he broke free of the urbane world of Impressionism. In the peasant simplicity of provincial life he not only discovered an inexhaustible source of subjects but also began to take his own artistic bearings from the unaffected originality of folk art.

The age of the great world fairs, entranced by prospects of progress and a future of technological well-being, was not without its awareness of an alternative world of peace and harmony which industrialization threatened with extinction. That other world was elsewhere; not in the urban civilization of the modern cities but in provincial backwaters and above all in the unspoilt reaches of faraway continents. *Bourgeois* society was tirelessly hardworking and had grown rich through its efforts. But it was intoxicated by visions of remote and magical worlds — as long as they stayed remote. Art was just the place for such visions. Paintings took to wearing exotic garb and showing mysterious and colourful things which excited the public's longings. The world of these paintings was artificial; it was a sensational world as far from the reality of the tropics as the tropics were from Paris.

Gauguin too had fallen under the spell. In his art, however, he aimed to portray a primitive world on its own terms, stripped of exotic props and without the cottage romanticism of peasant idylls. He was out to show the genuine, unposed, original character of subjects drawn from an unfamiliar, simple world. If the impression they made was also one of rudimentary crudeness, so be it; their very lack of refined sophistication was the guarantee of their authenticity.

During his quest for a primitivist method in Brittany, Gauguin had hit upon a new style: Cloisonnism. He developed this style at Pont-Aven together with one of his fellow-painters, Emile Bernard. The name came from a mediaeval enamelling technique in which the individual surfaces were compartmented off in fillets of metal. Similarly, the two painters took to contouring all their colour surfaces with thick lines of colour, with a rigour that verged on the dogmatic. The graphic line acquired as distinct a visual value as the area it encompassed. Naturally it was still representational art, and the lines and surfaces still clearly depicted recognizable figures and objects; but at the same

Head of a Negress, 1887
Pastel, 36 × 27 cm
Rijksmuseum Vincent van Gogh, Amsterdam

Madeleine Bernard, 1888
Oil on canvas, 72 × 58 cm
Musée de Peinture et de Sculpture, Grenoble

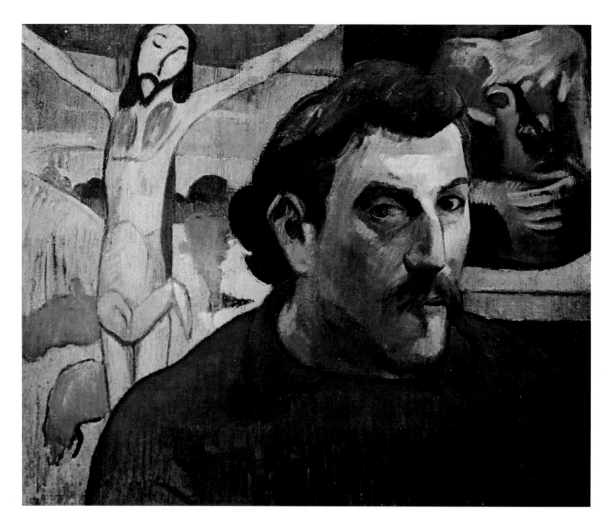

Self-Portrait with Yellow Christ, 1889
Oil on canvas, 38 × 46 cm
Maurice Denis family collection,
Saint-Germain-en-Laye

Dominating the foreground, and almost obstructing our view of the rest, is a group of women in traditional Breton costume, reverently meditating on the sermon they have been listening to. In the background, though, we see an angel with wings outstretched locked in combat with the Biblical figure of Jacob. Gauguin combines an everyday scene of women leaving church with a supernatural scene which exists only in the realm of faith, and in doing so he is also combining two different pictorial traditions. The tranquil and rough-hewn style of folk art has influenced the large figures in the fore-ground, while the dramatic struggle in the background draws on tradi-tions in Christian art. A third element is provided by the tree, with its axis function reminiscent of Oriental art. The painting makes a direct appeal to a world beyond the senses, and in doing so has recourse to singularly apt artistic means: hard and contrasting colours, a perspec-tive that draws us deeply into the background, together with a power-ful emphasis on the foreground, and large, compact areas of colour that only suggest the figures. These artistic means do not represent

things as they are so much as evoke a particular mood. Gauguin was trying to show a vision, but at the same time his painting aims quite simply to *be* a vision.

This painting (at the very latest) established Gauguin as the presiding spririt of the Pont-Aven painters' colony. The group included Paul Sérusier, Laval, Louis Anquetin, Armand Seguin, Jacob Meyer de Haan and of course Emile Bernard. The muse who inspired them was Emile's sister Madeleine, Laval's fiancée. Gauguin kept up a lively correspondence with her, which must have become rather too intense, since Madeleine's parents finally urged her to break it off. Gauguin still had a portrait to remember her by (p. 16), which he had painted in 1888.

Another painter had quit Paris at the same time as Gauguin: Vincent van Gogh. He had headed south, to Arles in Provence, where the shimmering light and the sunlit natural world provided him with inspiration for his work. Van Gogh had already had quite enough of the bare simplicity Gauguin sought in Brittany, in his own Dutch childhood. The two artists shared not only their escape into the provinces but also their plans to found an artists' colony. Gauguin's work alongside his fellow-artists had given him a new self-confidence; van Gogh, on the

Vision after the Sermon:
Jacob Wrestling with the Angel, 1888
Oil on canvas, 73 × 92 cm
National Gallery of Scotland, Edinburgh

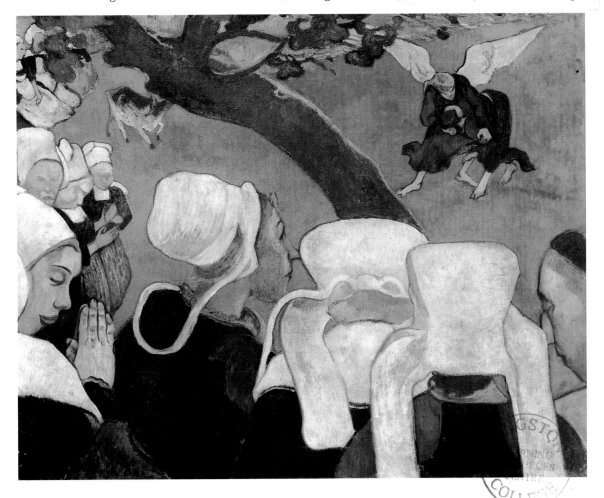

Night Café at Arles, 1888
Oil on canvas, 73 × 92 cm
Pushkin Museum, Moscow

other hand, had hitherto remained alone, and now had plans for the two loners to work together for a few months. His brother Theo, who represented both van Gogh and Gauguin in his capacity as a Montmartre art dealer in Paris, was to see to the arrangements. Weeks in advance, Vincent was already beside himself with excitement. He renovated and prettified his "yellow house" so that Gauguin would have everything he required. Gauguin, however, repeatedly delayed his arrival in Provence, apparently suspecting his dealer of a business ruse: "Theo likes me, but still he wouldn't agree to support me in the Midi just because I have a pretty face. He is a cool Dutchman, he has worked out what's what, and he is out to get the best, exclusive deal out of it."

As always, though, Gauguin was in debt. Theo came to the financial rescue one more time; and then there was nothing for it, and on 23 October 1888 Gauguin joined van Gogh at Arles. Two months of fighting and quarrelling ensued, during which each painter jealously tried to establish the superiority of his own work. Van Gogh had had a high opinion of his fellow-artist: "Everything he does is tender, moving,

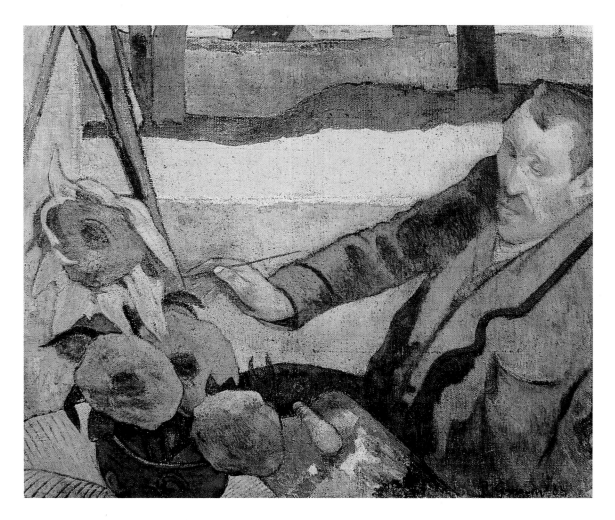

Van Gogh painting Sunflowers, 1888
Oil on canvas, 73 × 91 cm
Rijksmuseum Vincent van Gogh, Amsterdam

astonishing. People do not understand him yet, and he is suffering from his inability to sell – like other true poetic spirits." Their differences, however, grew increasingly obvious. "He is a Romantic," noted Gauguin irritably, "whereas my preferences lie with primitive art. When he applies paint he loves the chance effects of impasto, but I for my part detest disorderly workmanship." Gauguin had hoped to find a keen pupil to boss around. In fact, both had travelled too far along their respective ways as painters to achieve any deeper mutual understanding.

During their period together, van Gogh and Gauguin worked on the same subjects in a spirit of competition. Each would try his hand at the other's works, as a kind of test. *Night Café at Arles* (p. 22) shows Gauguin interpreting one of van Gogh's paintings – or, to be exact, two: *The All-Night Café* and the portrait of its owner, Madame Ginoux. The combination highlights Gauguin's knack of juxtaposing different motifs. The impression of desolate and overwhelming loneliness which made van Gogh's version of the café inimitably his own has disappeared from Gauguin's treatment. Van Gogh had seen the iso-

Women from Arles in the Public Garden, the Mistral, 1888
Oil on canvas, 72 × 93 cm
Art Institute of Chicago, Chicago

lated and nameless customers huddled in the corners as his true subject, but Gauguin banishes them to the background, behind the proprietress: She is presented gazing out of the picture, in a manner that eases contact and relieves that oppressive sense of isolation with which van Gogh had invested the café. Gauguin's attention was not on the darker aspects of life, and he preferred to pursue the lighter sides of the imagination.

He had seen van Gogh as a Romantic and himself as a primitivist, and it was certainly true that Vincent's art was as impetuous and vehement as the man himself. Van Gogh was in all things a man of feeling, passionately devoted to an art of expressive intensity. His impulsive will refused to pause before the fearful abysses in the soul of man. Gauguin's involvement with the human condition was marked by distance (comparatively speaking). His watchwords were happiness and harmony, and he arrived at them not through any struggle within himself but by yielding to the alien promises of edenic worlds. Gauguin's art was an art of suggestion, vividly conjuring up realms of alternative realities which lay beyond his ken. Van Gogh's was a more

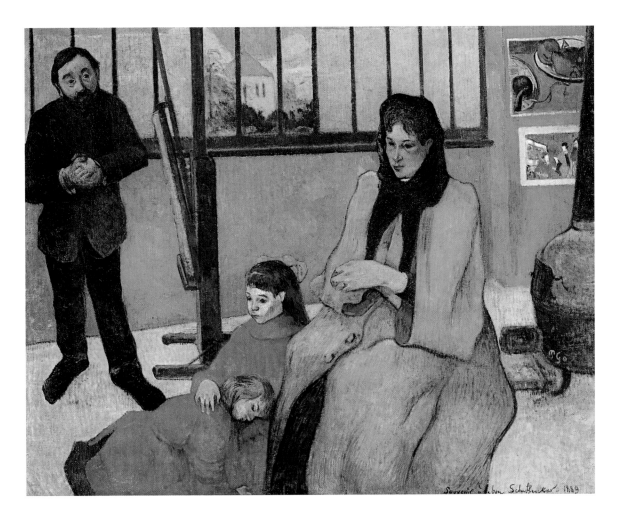

The Schuffenecker Family, 1889
Oil on canvas, 73 × 92 cm
Musée d'Orsay, Paris

introspective art, an art of expression that was centred on his own personality and problems.

The break was not long in coming. "Ever since I had decided I wanted to leave Arles," wrote Gauguin, "he had been behaving so oddly that I scarcely dared breathe. 'You want to go,' he said, and when I replied 'Yes' he tore off a strip of newspaper bearing the following words and handed it to me: 'The murderer has fled.'" For van Gogh, it meant the collapse of his hopes for relaxed work with fellow-artists in the southern sun. At night he would often get up and creep into Gauguin's room to reassure himself that the other was still there. It was only Vincent's illness that still kept Gauguin in Arles: "Though we are at odds on some things, I cannot be angry at a good fellow who is sick and suffering and needs me."

On 23 December, exactly two months after Gauguin's arrival, the state of affairs grew dramatically worse. Gauguin went out for an evening stroll, and Vincent, forever suspicious, followed him. Gauguin heard his familiar footfall, turned, gazed into van Gogh's distraught face, and supposedly saw an open razor in his hand. Vincent instantly

The Yellow Christ, 1889
Study for the painting in Buffalo
Watercolour, 15.2 × 12.1 cm
Chapman collection, New York

The Yellow Christ, 1889
Oil on canvas, 92 × 73 cm
Albright-Knox Art Gallery, Buffalo (N.Y.)

turned and ran home, and Gauguin, somewhat disturbed, spent the night in a hotel. Next morning, as he was about to return to the "yellow house", he found the whole of Arles in an uproar: once he was at home, Vincent, tormented by hallucinations and pain, had cut off his left ear-lobe, with the very razor Gauguin claimed to have seen him carrying. After he had stanched the flow of blood, van Gogh had wrapped the severed lobe in a handkerchief and hurried to the town brothel, where he gave it to one of the prostitutes. He then walked home and went to bed as if nothing had happened. And there the police found him when they were alerted early in the morning. He was taken to hospital.

At the time, Gauguin had just completed *Van Gogh Painting Sunflowers* (p. 23). In his fellow-painter's portrayal, van Gogh has a wild look and his brush arm is stretched out awkwardly. Gauguin was trying to capture that manic compulsion which drove van Gogh to paint, and the way his paintings seemed almost to make themselves. "It really is me," van Gogh commented, "though it looks as if I had gone mad." And in fact the Gauguin affair was the straw that broke the camel's back: van Gogh became profoundly sick, and his time with Gauguin was his last at total liberty. The brief spell that remained to van Gogh in his short life was mostly to be spent in confinement. Gauguin, meanwhile, left Arles the same morning, without seeing the other artist again. His prompt retreat looked distinctly shamefaced; though later, in his book *Avant et après,* Gauguin justified his conduct by claiming Vincent had threatened him with the razor. At all events, the episode was not inconveniently timed from Gauguin's point of view: now no one stood between him and the wide world any more. The van Gogh adventure nicely exemplifies a certain man-of-the-world wiliness that constantly accompanied Gauguin's artistic endeavours. He was always capable of keeping his distance. Gauguin too saw the unison of art and life as his goal; but van Gogh's attempt to reach that goal was the more earnest of the two. Gauguin wrote off the time he hed spent in Arles as a bad experience and as a strategic concession to his dealer, Theo van Gogh.

Gauguin began 1889 in Paris. He had fled to this old friend Schuffenecker — "le bon Schuff", as he affectionately called him — who had taken a job as a drawing teacher after the stock exchange crash. Schuffenecker had abandoned his artistic ambitions for a steady income, and now seemed to be a happy family man. Aptly enough, Gauguin therefore painted his friend in the family circle: indeed, in *The Schuffenecker Family* (p. 25) Claude Emile's wife and children are the central figures. Typically for Gauguin, they are positioned emphatically up front, even cropped by the edge of the picture. Gauguin's friend, on the other hand, is standing discreetly aside by the easel, as if he too intended to paint the mother and children. He is looking at his family with a curious, almost fearful gaze. Schuffenecker's fears may not have been altogether unfounded; at any rate, she and Gauguin are said to have had intimate talks. The composition, with its massively dominant female figure and the timid man in the background, is certainly unusual: the artist has used his

26

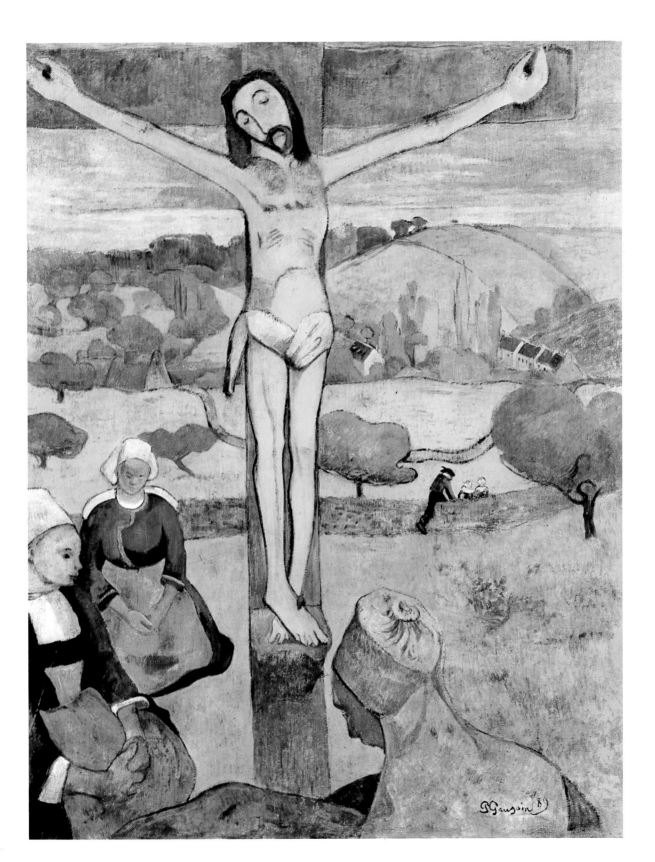

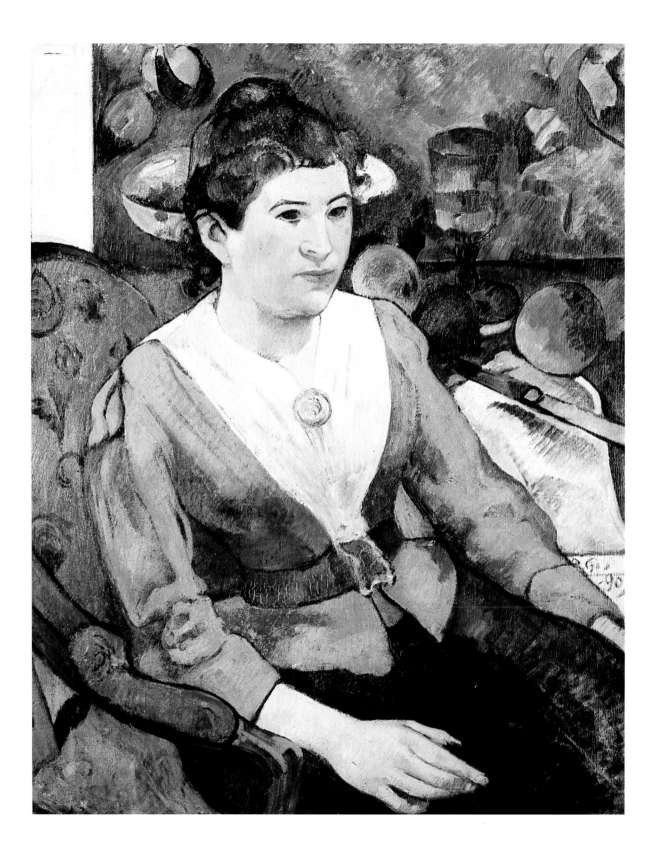

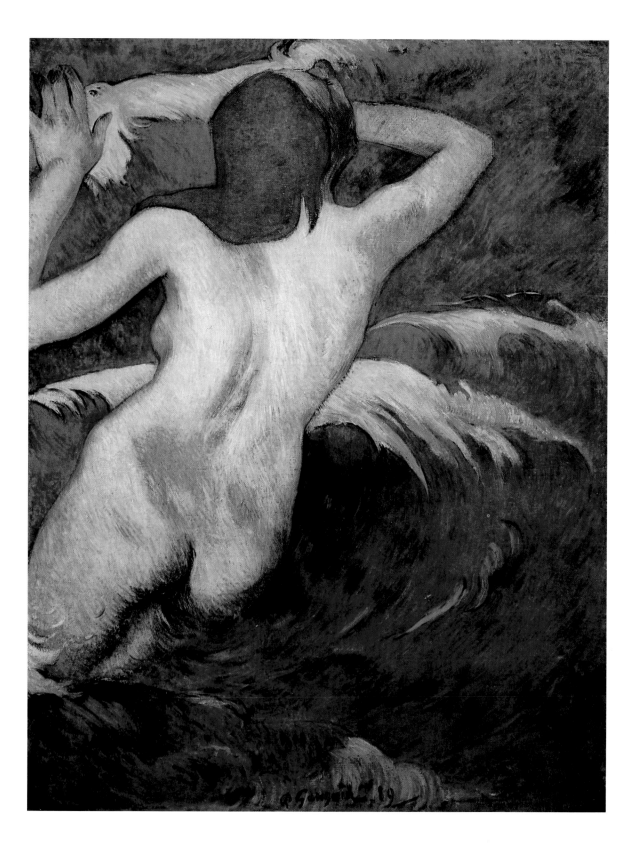

artist's head at the centre. There is no sense of spatial dimensions in the free flow of colours in the background. Three Christian symbols — the apple, the halo and the snake — bridge the gap between representation and abstraction; and it is their association of sin and redemption which those symbols conjure up which make us see Gauguin's painting with greater sympathy. What emerges from the combination of a seemingly unambiguous expression of woe and decorative elements apparently devoid of meaning is an evocative portrayal of the enigmatic character of the artist.

In the years 1888 to 1891, Gauguin was wholly under the influence of an artistic circle whose avowed aims were to be more inventive, more individual, and quite simply more *different,* than anyone else. They were dandies who liked to stroll about the streets of Paris eccentrically and strikingly dressed, revelling in the feeling of being outsiders. Writers such as Stéphane Mallarmé and Paul Verlaine were the heart of this circle, and Gauguin belonged to it too. Every Tuesday evening there was a *soirée* at Mallarmé's where the latest fashions were discussed and plans were made to capture the public limelight with further sensations. Jean Moréas had published the Symbolist

Fair Harvest, 1889
Oil on canvas, 73 × 92 cm
Musée d'Orsay, Paris

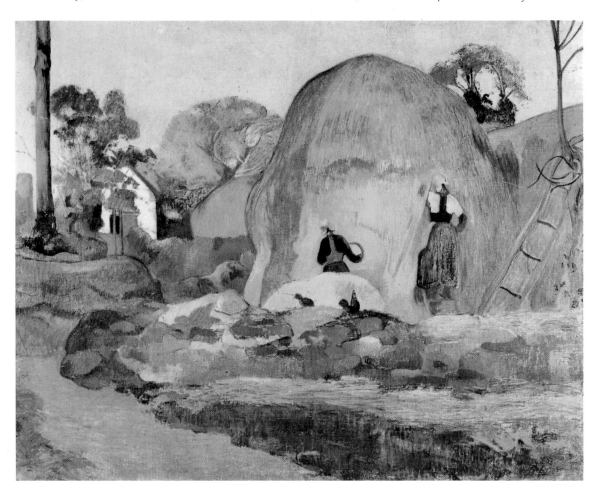

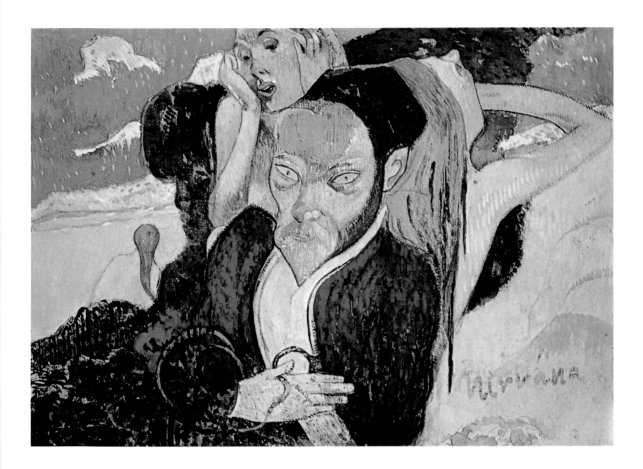

Nirvana, Portrait of Meyer de Haan, 1889
Oil and tempera on silk, 20 × 29 cm
Wadsworth Atheneum, Hartford (Conn.)

Manifesto in 1886, and that had given the clique its name: the Symbolists. They aired their views in the *Mercure de France,* which published Albert Aurier, the only critic to have taken note of van Gogh during his lifetime. What linked these individualists was their somewhat forced pose of being ahead of their time; affinities united them, however they might disagree on current affairs. In due course, protesting against the movement's obsession with grandeur, Gauguin observed that Symbolism was "no more than another name for a deficient response to life". Still, his paintings of the period demand the same sensitive empathy as Symbolism, irrespective of theoretical notions. And his visionary works require the public to be in tune with him, and prepared to accept the suggestiveness of different and profounder worlds. If we do not grasp his art instantly, we never shall.

Emile Aurier's essay 'Gauguin, or The Symbolist Movement in Painting' was the circle's farewell present when Gauguin departed for the tropics for the second time. It appeared in the March 1891 issue of *Mercure de France* and — ironically enough — used Gauguin's work in order to illustrate the programmatic tenets of Symbolism. Aurier declared that a work of art must possess five characteristics in order to the Symbolist, characteristics which Gauguin's paintings naturally had.

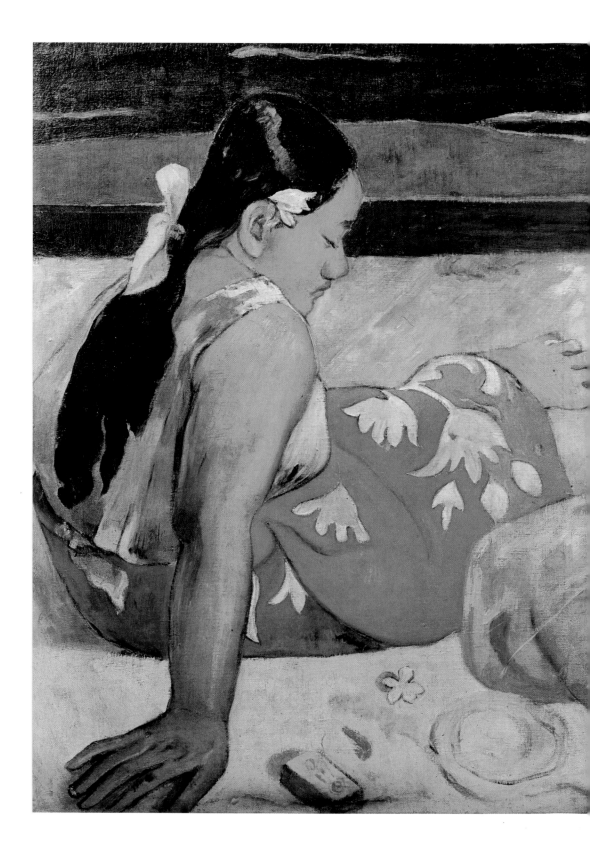

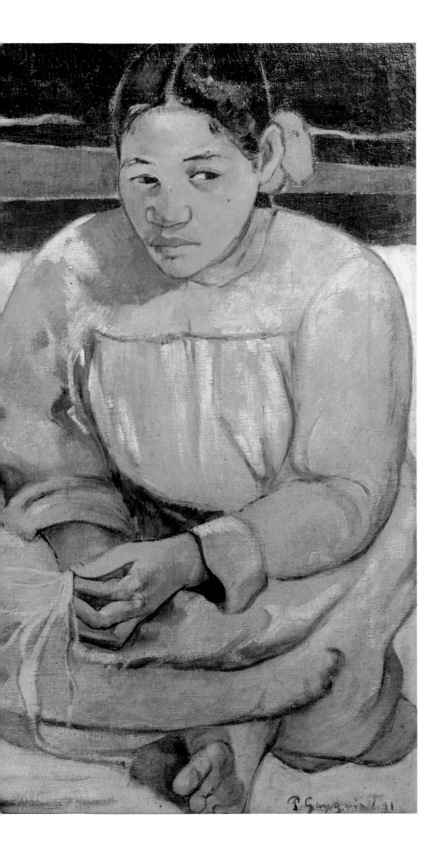

Two women on the Beach, 1891
Oil on canvas,
69 × 91.5 cm
Musée d'Orsay, Paris

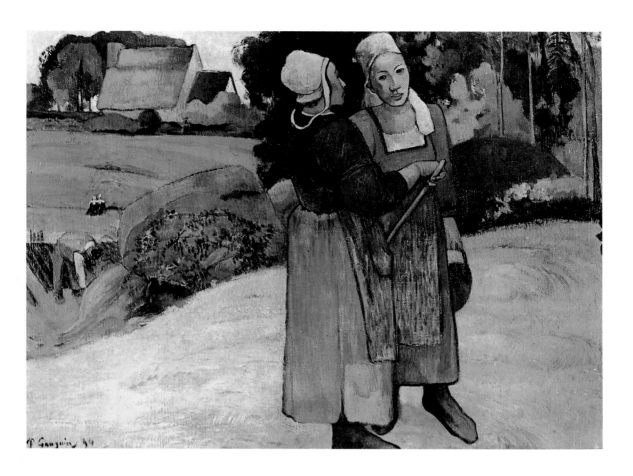

Two Breton Women on the Road, 1894
Oil on canvas, 66 × 93 cm
Musée d'Orsay, Paris

place of love"). This was to be the kind of bohemian rendezvous which Mallarmé had hosted years before.

His image required that he should have an exotic lover, and Gauguin had one in Anna, the Javanese girl, who would dance with a little monkey for society gentlemen. In *Anna the Javanese* (p. 58) Gauguin aiming at the same unforced, natural nakedness as in his portraits of Tahitian women. But this time the relaxed animal quality doesn't quite come off. This woman, clothed by Nature in innocence, has not undressed — she has *been* undressed, by the covetous eyes of male society. In Paris, her very body helped create an image of exotic magic, and that is what she personifies in the painting. It is no chance (as it might be in the South Seas) that the little monkey is sitting at her feet; it is there as her attribute, to ensure that she will be recognized. Doubtless it pleased Gauguin to enhance his own image with the decorative Anna; but in this work he was unable to give effective artistic expression to that direct fascination with the beauty of local women which had given such distinctive power to some of his Tahiti pictures. The painting seems as contrived as the exotic atmosphere of the artist's studio.

In Paris, Gauguin liked to encourage notions of the artist as one who envisioned a better world, and the book edition of *Noa Noa* fitted

splendidly. It was conceived as an artist's diary, with its gaze firmly fixed on the tropics, and despising the reality of its own origins. *Noa Noa* is not an especially truthful book, but that is beside the point. Gauguin merely needed a consistent narrative, and a story that matched his attention-getting public image. He had made a diplomatic peace with Morice, and the critic wrote a few poems for the book. And Gauguin took on the task of illustrating it himself.

In the watercolour *The Messengers of Oro* (below) we sense something of Gauguin's mood at that time. It tells of events immediately preceding the episode Gauguin presented in *Her Name is Vairaumati*. The two sisters of the supreme god Oro are telling the young virgin cowering on the ground of Taaroa's wish to take her as his bride. Back home, Gauguin was still dwelling on images seen in the South Seas. Instead of being receptive to new subjects, he was drawing on a repertoire acquired during the past few years. He was hoping, of course, that he would overwhelm the art world. But in fact this divorce

The Messengers of Oro, 1893
Illustration for 'L'Ancien culte mahorie', leaf 24
Watercolour, 14 × 17 cm
Département des Arts graphiques, Musée National du Louvre, Paris

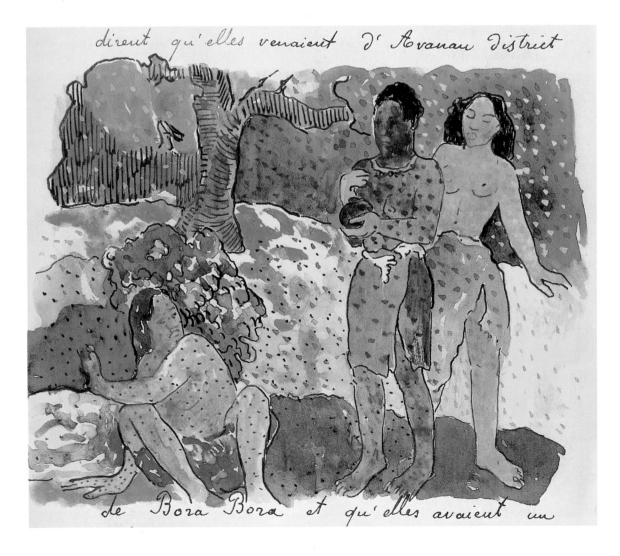

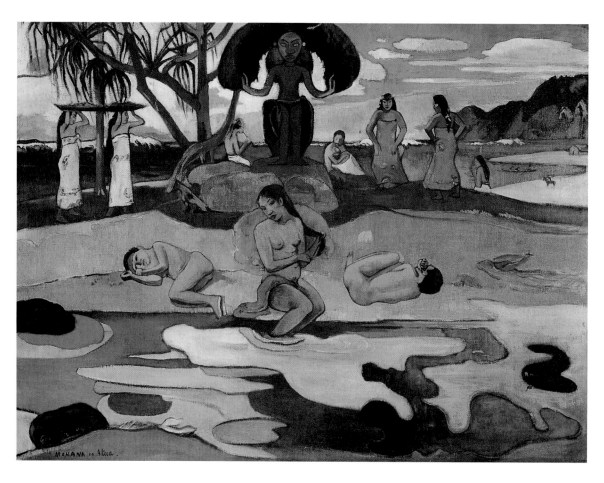

Day of God (Mahana no Atua), ca. 1894
Oil on canvas, 66 × 87 cm
Art Institute of Chicago, Chicago

friends got into a squabble with some children. Local sailors came to the youngsters' assistance, and in the ensuing brawl Gauguin broke his ankle. The foot was never to heal fully, and in fact, gave him considerable pain during the last years of his life. While he was being looked after in hospital, Anna deserted him, first ransacking the flat they had shared in Paris.

The Concarneau brawl resulted in legal proceedings, which Gauguin lost, just as he lost an attempt to make dealers and friends restore his own works to him. The experience left him determined to avoid future disappointment at the hands of civilization: "Nothing will stop me leaving, and this time it will be for good. What an idiotic existence life in Europe is."

Maybe Gauguin would have been appeased if his auction of work (to finance his departure) had been more of a success. But this time the auction, held at the Hôtel Drouot in Paris, was a disaster, and he sold almost nothing. Gauguin had to buy his own pictures to meet the asking price. Friends also left him in the lurch. He had asked dramatist August Strindberg to write a catalogue preface for the sale, but the Swede, declining the invitation, expressed himself suggestively: "Monsieur Gauguin, I said in a dream, you have created a new earth

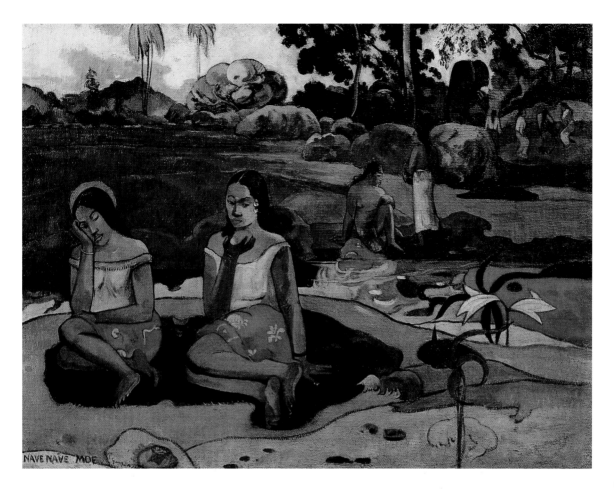

NAVE NAVE MOE

and a new heaven. But I do not like what you have created." So Paul Gauguin at last felt totally deserted. He had returned to Europe full of hope, prepared to play the fashionable game of exotic magic, but he was unable to play the game as wholeheartedly and relentlessly as the public expected. He was too committed to the truth of his vision of the tropics. Failure was inevitable. There was nothing to keep him in Europe any longer. And when he left, he left an angry man.

Delicious Water (Nave Nave Moe), 1894
Oil on canvas, 73 × 98 cm
Hermitage, Leningrad

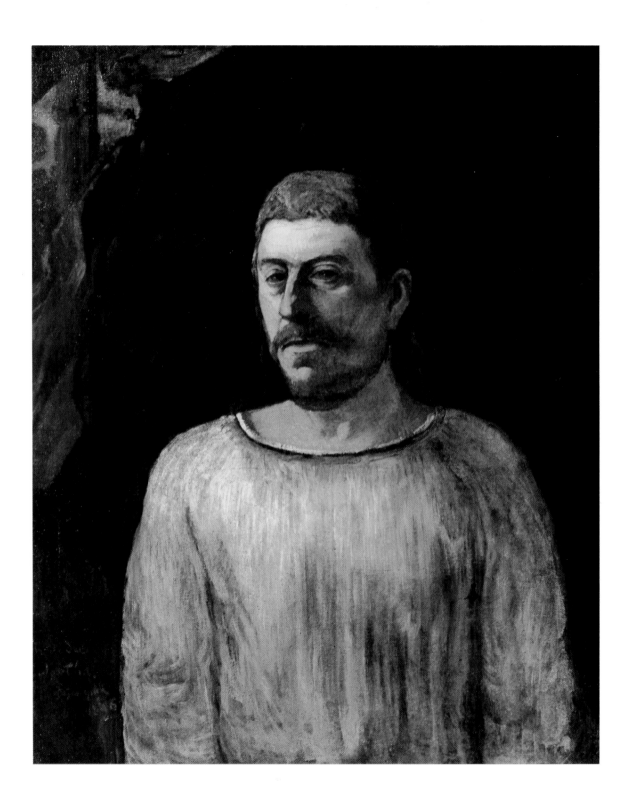

The Legacy of the Tropics
1895–1903

"Paul Gauguin has no cause to be proud of his fellow-countrymen. Those who were astonished some years ago when he chose Tahiti as an idyllic exile where he could work in peace and sunshine might seek the reasons for his second departure in the ingratitude with which they themselves responded to a man whose life's work and reputation are among our most valuable possessions."

Thus wrote a chastened Morice, when he heard the news that Gauguin had once again quietly departed from France, without a hint of going-away festivities.

Morice was one of the few that viewed his course positively. Most of Gauguin's fellow-artists felt immensely provoked by his approach: after all, they too were convinced that they had a mission to revolutionize art, but they wanted the grand upheaval to take place on their Parisian home ground if at all possible, or during their summer vacations in the provinces. Inevitably Gauguin antagonized them; his relentless pursuit of outsider status was a continuous and pointed reminder of their own indolence. Deep down, they may well have heaved a sight of relief to be rid of their friend.

Gauguin's voyage to the other side of the world took three months. He made it in a spirit of disillusionment, and in the event it was to be a journey of no return. Henceforth, the artist preserved only letter contact with France, normally on a monthly basis. The return to the home country had not provided the inspiration he was constantly in search of, and the increasing daring and freedom of his art had gone largely unrecognised in society. The fact that some of his fellow-artists did indeed value his achievement was of little direct assistance in the day-to-day business of living.

Things had changed somewhat in Tahiti. The town of Papeete had had electricity laid on and had acquired a new governor, a more flexible spirit with whom Gauguin toured the island. At first the painter was filled with optimism about his new life in the tropics; though there were those back home who had their doubts.

His old friend Schuffenecker, reviewing the course, which events had taken, wrote to Gauguin: "If you had been clever and planned ahead, you would now be leading a pleasant, carefree life." In other words: if you had proved more adaptable, the public would have rewarded you accordingly.

Mysterious Water (Pape Moe), 1893
Watercolour, 31.8 × 21.6 cm
Art Institute of Chicago, Chicago

Self-Portrait, 1896
Oil on canvas, 76 × 64 cm
Museo de Arte, São Paolo

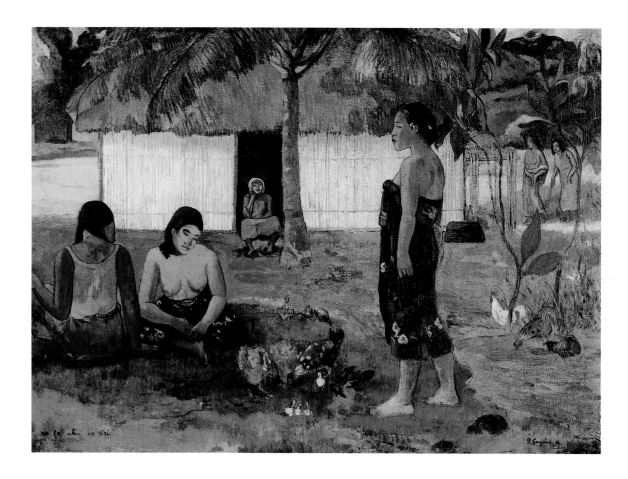

Why are you angry? No te aha oe riri?, 1896
Oil on canvas, 95.3 × 130.5 cm
Art Institute of Chicago, Chicago

But this criticism was first and foremost that of a conformist who had abandoned art for a safe job as an art teacher, and Gauguin could hardly accept it. "I never intended to go cap in hand to the state," wrote the painter. "Everything I struggled for outside the realm of officialdom, and the dignity I have tried hard my whole life long to maintain, have become worthless from this day forth. From now on I am no more than a schemer and a big-mouth. But if I had given in — yes, then I would be sitting pretty."

Working himself up into a fury, he cast himself in the role of a monster: "I shall end my days here in my peaceful hut — yes, I am an awful wrong-doer. So be it! So was Michelangelo — and I am not Michelangelo!" That proverbial *terribilità* which at one fine raged volcanically within the Renaissance hero was now exported to the South Seas in the exile's baggage.

The artistic avant-garde has always envisaged society as a strait-jacket, imposing limits on the freedom of the imagination. The avante-garde sees the possibility of creativity as existing only in opposition to the state's models and norms. The artist dons the garb of genius and proclaims a freedom which (as he knows) cannot be available to all. If he is to justify his demand for societal freedom, he

must needs insist on his calling, his vocation. Gauguin too found himself manoeuvred into this position. And, on top of it, he tended increasingly to give himself a martyr's airs: "What did it get me? Total defeat, and enemies – that's all. Bad luck has been dogging my heels my whole life long, and the further I go on the deeper I sink."

Thus in the *Self-Portrait* (p. 66) we see Gauguin posing as Christ once again. This time however, he attempted no self-satisfied comparison with the Christian God. The artist's gaze was one of straightforward accusation. "This terrible society which we are forced to endure, where little men emerge triumphant at the expense of great, is our Calvary," he wrote three years later. But he was not only attacking his favourite enemy, the Old World. The portrait is set against a dark and impenetrable background where two vague figures are appearing, constant companions from the realm of the shades of Death. The artist looks calm, resigned to his fate as outsider, a man

Eiaha Ohipa (Not Working), 1896
Oil on canvas, 65 × 75 cm
Pushkin Museum, Moscow

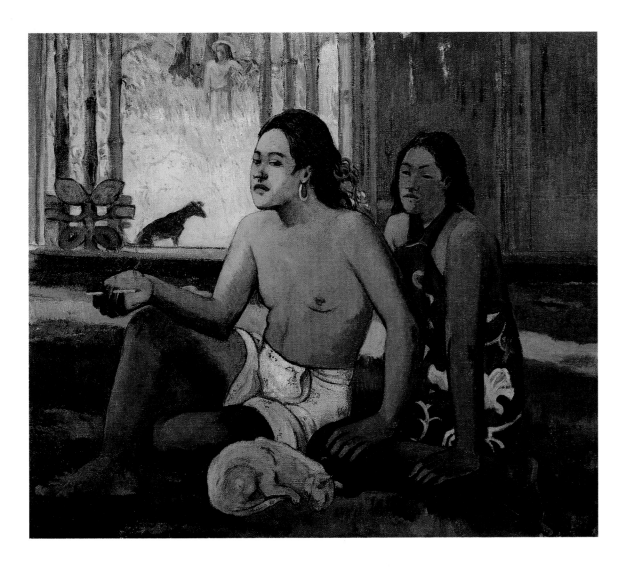

like any other: helpless and defenceless. After years of searching, Gauguin had at last found in this Janus face an emblematic portrayal of life itself. His sensitivity towards the special status of the artist who is certain of his visionary faculty merged with an admission of that frailty he shared with all men, be they primitive or civilized. Caught between loneliness and solidarity, Gauguin began to accept himself: "Laughing, you climb your Calvary, your legs shake under the weight of the cross; at the top you grind your teeth, and then, smiling, you take your revenge," he wrote cryptically in *Avant et après,* his memoirs of the closing years of his life.

Since the thought of hanging his work on western walls no longer dominated his thinking so much, Gauguin's pictures were now quite often of monumental size, and lost that aura of contrivance and artifice which had seemed programmatic and forced in his earlier South Seas work. He continued to send his paintings to his European agent, Daniel de Monfreid; but now Gauguin abandoned the misconceptions which, after his repeated failure, he ought to have given up long before. Now he paid attention to a voice within, to a need for truth. Now he increasingly refused to strike artistic compromises between the gentle naturalness of the local people and the expectations of his European audience.

And now Gauguin attempted comparisons of ways of life, trying to analyse in detail the respects in which the civilized and primitive worlds differed. *Eiaha Ohipa* (p. 69), for example, contrasts the Euro-

Still Life with Mangoes, 1896
Oil on canvas,
private collection

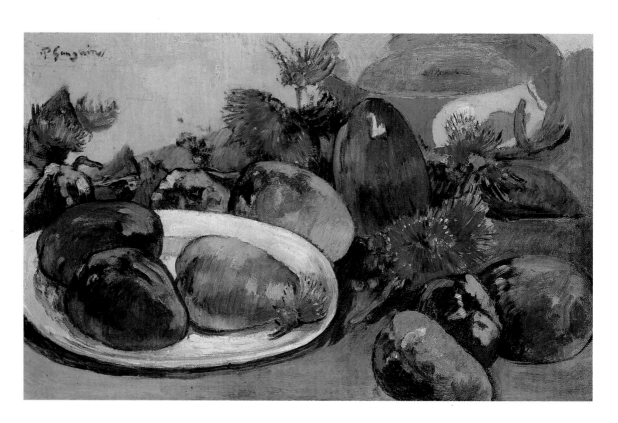

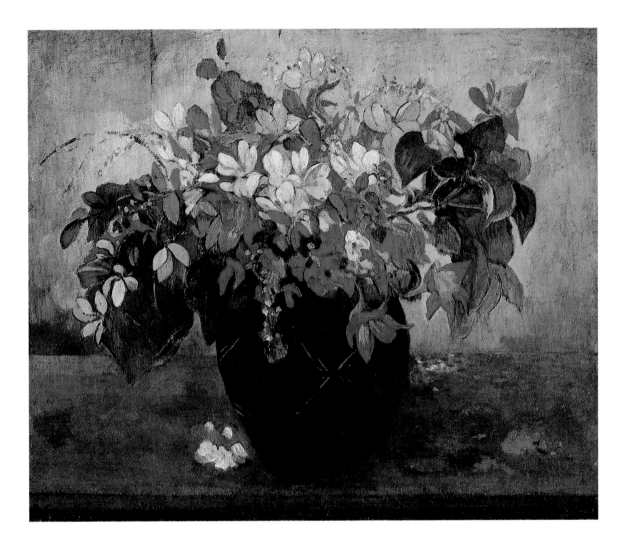

Bouquet of Flowers, 1896
Oil on canvas, 63 × 73 cm
National Gallery of Art, London

pean work ethic (which still had Gauguin himself in its grip) with the Tahitian tendency to take things as they came. Two Tahitians are sitting in their hut, sleepily enjoying their tobacco. There are no tools or materials to prompt them to hard work. In the background, a figure in a long, white robe, with a topee on his head, is seen approaching — none other than the artist himself. Searching for subjects (that is, for things that will set him working) he has hit upon the theme of work; and now he produces affectionate sketches of a world devoted to doing nothing, to idleness of a kind he himself is incapable of. The artist lacks the natural, animal freedom of these people, who are indeed so like the animals (and all of creation) — animals such as the cat, sleepy and unself-conscious too, and without any fear of doing the wrong thing.

"When I am tired of painting human figures (which is what I prefer), I start a still life and complete it without referring to the objects again," Gauguin wrote to the Russian Prince Emanuel Bibesco, one of his

Queen of Beauty (Te Arii Vahine), 1896
Watercolour, 17.2 × 22.9 cm
Private collection, New York

collectors. (There were a number of Gauguin collectors, in spite of the artist's setbacks.) He wrote of still lifes as if painting them were relaxation: clearly leisure was not synonymous with idleness for Gauguin. Whatever he may at times have said, he was no native, and had his work ethic. *Still Life with Mangoes* (p. 70) and *Bouquet of Flowers* (p. 71) show Gauguin in holiday mood. He presents flowers and fruits in the same way as people, with vivid immediacy and a sensuous fascination; whether animate or inanimate, everything in creation is a part of nature.

Gauguin soon moved away from the Tahitian capital Papeete, as he had done the first time. The influence of Europe was worse than ever: now electricity had been introduced to the island. Once again, Gauguin moved to the interior, into a frail and rickety native-style hut exposed to the elements.

"I have straw matting and my old Persian carpet on the floor," he wrote to Monfreid. "The place is adorned with materials, knick-knacks and drawings." This time Gauguin had to do without his lover Tehura, since she had got married in the meantime. Still, he wrote to friends that "girls come to my bed every night as if possessed", doubtless intending to prompt envy back home. His new lover was a fourteen-

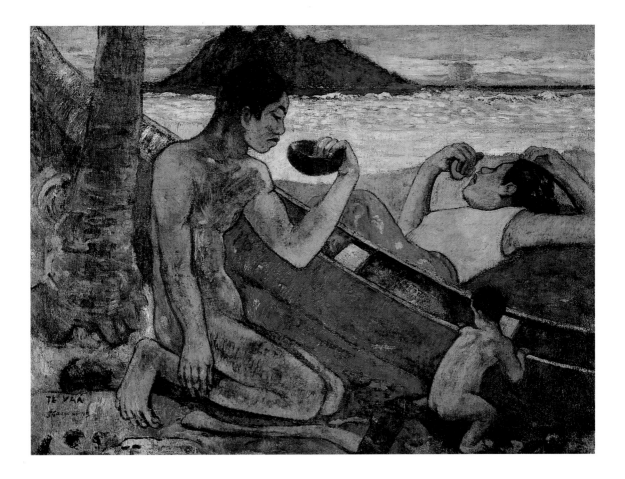

The Dug-Out (Te Vaa), 1896
Oil on canvas, 96 × 130 cm
Hermitage, Leningrad

year-old called Pau'ura. His love life, however, was plagued by an unpleasant legacy from France: shortly before leaving Paris he had contracted syphilis, and now he found himself introducing his dearly-loved paradise to one of civilization's more dubious blessings – he passed on the disease to the Polynesians.

The beautiful female nudes that constitute the major part of Gauguin's late work might almost have been meant to illustrate his tales of girls succumbing to his erotic charisma. Thus *Queen of Beauty* (p. 72), a watercolour study for the oil *Woman with Mangoes* in the Leningrad Hermitage, shows the girl in a pose familiar from European art, lying on the grass in the same way as Goya's *Naked Maya* (Prado, Madrid) or Manet's *Olympia* lay on their vast beds. Her legs are crossed and she is covering her privates with her hand, offering herself in the same may as Goya's and Manet's lascivious goddesses of love did; but Gauguin's beauty is not looking at us, and her averted gaze mitigates the seductiveness which lies in that ambiguously fascinating figure, the innocent temptress.

"The Eve of your civilized imagination makes you and almost all of us misogynists," Gauguin had replied to Strindberg; "the Eve of primitive times who, in my studio, startles you now, may one day smile on

you less bitterly." The strict sexual morality of the late 19th century always saw erotic charisma together with feelings of danger or even hatred. On Tahiti, Gauguin wanted to free himself of this unnatural attitude to love and desire, an attitude which emphasized divided, mixed feelings rather than an immediate response. He wanted an Eve who could be loved without guilt. This Eve was a product of male fantasies too; but an imaginary innocent Eve seemed free and available, and her lover felt like a man once more.

"They are gentle-spirited to the point of stupidity, and totally incapable of mean calculation," Gauguin wrote of his Polynesian friends and neighbours in *Avant et après*. He was wholeheartedly willing to see the innocent simplicity of the local people as the true human condition. His friendly reception on Tahiti was quite the opposite of the derision and brusque rejection he had suffered in Europe. And so he inevitably felt an affinity with the people of the South Seas. If every being under the sun had its own natural dignity, cruelty was easily forgotten: "Ask one of these sleepy ancients if he likes human meat and, with a twinkle in his eye, he will answer cheerfully and infinitely gently, 'Ah, how good it tastes!'" reports *Avant et après*. The cannibal who devours the body of his enemy (but only his enemy) behaves more

Nativity (Te Tamari No Atua), 1896
Oil on canvas, 96 × 128 cm
Neue Pinakothek, Munich

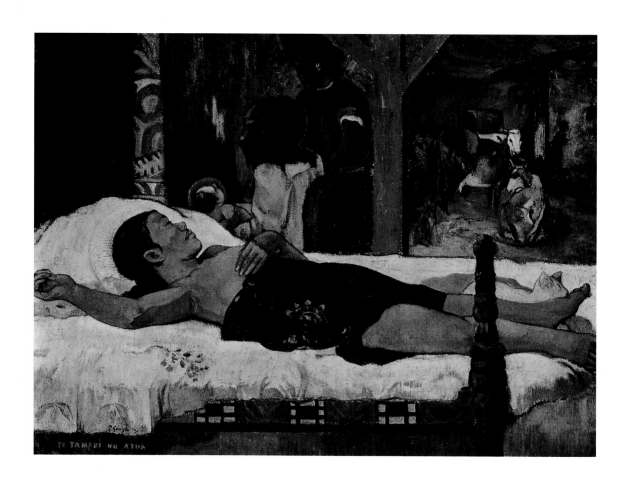

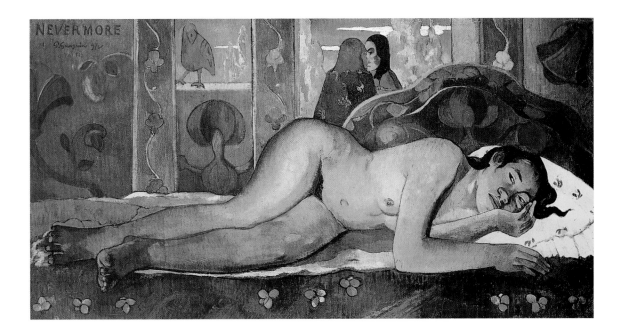

morally than western society, which calls itself humane but locks people up for life in asylums. "I no longer have any sense of days and hours, or of good and evil." On that peaceful island, with its own standards and values, no one troubled with appointments; and, since their lifes were lived in harmony with nature, they could not but be good.

Gauguin himself flouted western convention quite blatantly at times. He fathered illegitimate children, for instance: one was born before he left Paris, and another one year later on Tahiti. The happy event soon appeared in paintings with family, procreation and birth as their subjects. The everyday bliss of family life is Gauguin's theme in *The Dug-Out* (p. 73). People drinking out of bowls, and a rudimentary boat to carry them over the water: everything is simple. The axe at the man's feet indicates that he has just made the dug-out. The family can find everything they need in their environment, which appears as a veritable Shangri-la, bathed in harmonious sunset tones. In this world, things take care of themselves, it seems, and the people's faces are relaxed, trusting, and utterly contented. Given the pleasure and peacefulness which fill the picture, the traditional symbolic meaning of a boat as a way of overcoming dangers is scarcely important. The whole family conveys the message – a message of harmony.

Borrowing the tradition of Christian art in his familiar manner once again, Gauguin put his own experience of fatherhood into his *Nativity* (p. 74). Again a biblical story has been given a South Seas setting – a Polynesian hut with ornamental beams and a simple bed. The stable animals are there too. A native woman, probably Gauguin's lover, has been cast as the Mother of God. Like the newborn child being rocked by the nurse in the background, she has a halo.

Nevermore, O Taïti, 1897
Oil on canvas, 59.5 × 116 cm
Courtauld Institute Galleries, London

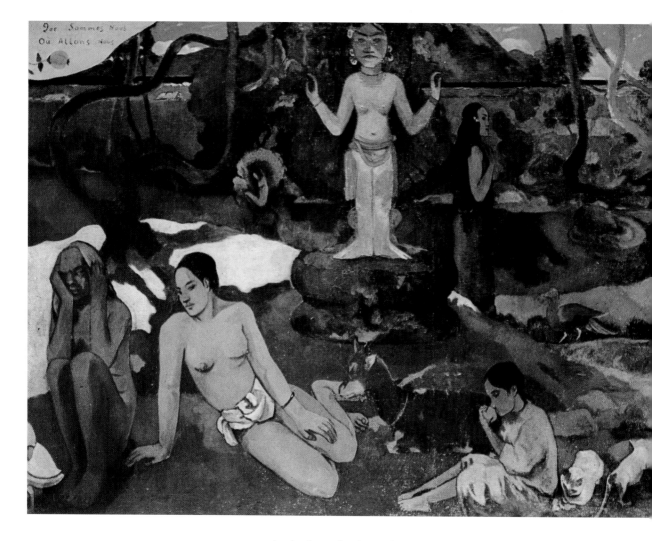

Again the artist draws a parallel between himself and the Christian
God, though this time he has cast himself in the role of creator rather
than sufferer. In this painting, Gauguin appears to be saying that the
life which he is able to create is not only a product of artistic activity:
at the end of his life, we see him once again proclaiming the values of
fatherhood, which had originally established the individual character
of his work. The serenity of the scene is resplendent and undimmed.
That first year on Tahiti was surely one of the happiest in Gauguin's
life.

But his situation soon deteriorated. Yet again he was plagued by
financial worries. With the help of friends, he had tried to establish a
group of patrons who would pay him an annual allowance in return for
a number of pictures; but the plan didn't work out. Instead of the
backing of wealthy patrons, Gauguin merely achieved a one-off grant
of 200 francs from the Minister of the Arts. Vexed by such a small
amount, the émigré returned the pittance in a temper.

Gauguin had no intention of begging. He longed for the recognition
his artistic achievement had earned him. Unfortunately, he could have

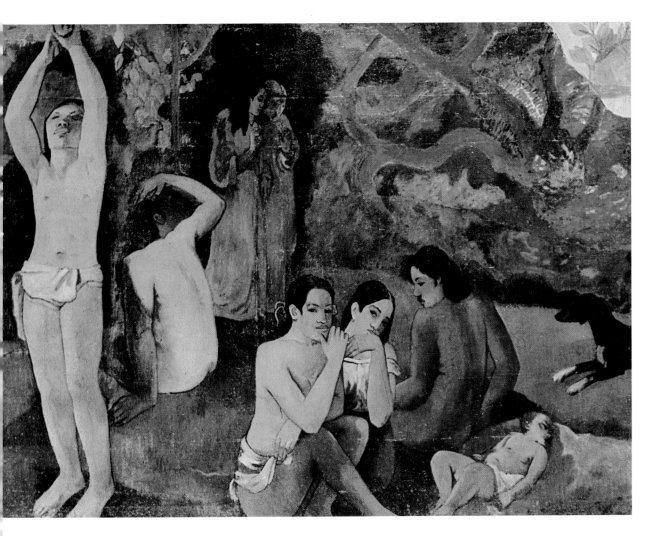

used the money: "My position is precarious and growing more and more unbearable, and, dreadful as it may be, I cannot afford protracted haggling. I shall have to sell my pictures for whatever price I can get."

In his self-imposed exile, Gauguin also knew that most of his paintings were unsaleable. When he sent *Woman with Mangoes* (compare the watercolour study on p. 72) to Europe, he wrote: "What's the point in sending this picture far away to join all the others that cannot be sold and only provoke howls of derision? This painting will only provoke still more derision. I am condemned to die of goodwill or hunger."

He reconsidered the possibility of adapting his work to public taste. To make matters worse, the broken ankle was giving him problems: his syphilis grew worse and turned into a running sore. Gauguin had to go into hospital for treatment which he could not pay for. His debts mounted.

Gauguin's new gloom promptly found expression in his work. *Nevermore, O Taïti* (p. 75) is another of his monumental nudes, with the

Where Do We Come From?
What Are We?
Where Are We Going? (D'où venons-nous? Que sommes-nous? Où allons-nous?), 1897
Oil on canvas, 139 × 375 cm
Museum of Fine Arts, Boston

Tahitian Women
Photograph, ca. 1890

blest: "I think everything that ought and ought not to be said about me has been said. All I want is silence, silence, and yet again silence. I want to be left to die peacefully and forgotten."

But Gauguin had not quite turned his back on the world of the living yet. He still had something he wanted to say, so that the contemptuous, mocking crowds would perceive his true worth when he was gone. And so he summoned up all his powers and created his major image of the human condition, *Where Do We Come From? What Are We? Where Are We Going?* (pp. 76/77).

With hardly any preparation he set to work. He had nothing more to lose, and therefore no inhibitions about using his brush with the clumsy crudeness that the critics damned as "over-primitive". He was out to fling one final affirmation of artistic force in the world's face. "I have put all my energy into it one more time before I die," he wrote: "so painful a passion in such dreadful circumstances, so clear and accurate a vision, that there is no trace of precociousness, and life blossoms forth from it." He wanted it to be "comparable with the Gospels": once again, he was ambitiously aiming for that quality of divinity which he so liked to adumbrate in his work, a quality of universality.

The spectrum of human activity encompassed by the painting spans all of life, from birth to death, in all its wondrous diversity. The newborn child lying in the grass, seeing the light of day for the first time, marks one boundary of Gauguin's stage, and the careworn old woman who looks so downcast as she meditates upon the past marks the other. Between the two lies the copious adult world of fears and joys. The exotic idol in the background, and the two people walking (possibly lovers), are there for atmospheric effect, and bridge the gap between Man and the natural setting. Gauguin reveals considerable ambition in the way in which he placed some favourite subjects in his panorama – the relaxed reclining nude, the figures sitting lost in thought, the cult statue. The figures are there to evoke associative meanings, rather than to explain or illustrate. Gauguin was not concerned with being understood: rather, he was interpreting life as a great mystery. The world's lack of understanding, which was pushing him towards suicide, was obliquely expressed in his emphasis of the impenetrable and incomprehensible.

Once he had completed this painting, his testament, Gauguin retreated into the hills to die, like a wounded animal. He took arsenic with him, intending to poison himself. His attempt at suicide was unsuccessful, though. Pathetically enough, Gauguin swallowed too much and promptly vomited the arsenic up again, so that the overdose had no very serious consequences. Somehow or other he managed to get back to town, where he was taken to hospital, a sick man.

Gradually he recovered. His circumstances had not improved, and deportation threatened if he could not pay his debts, so he was obliged to take the kind of routine job he hated so much, working in a creditor's office. In the mean time, Monfreid succeeded in selling *Where Do We Come From? What Are We? Where Are We Going?* The painting, which had proved not to be a testament after all, brought

Two Tahitian Women with Mango Blossoms, 1899
Oil on canvas, 94 × 72 cm
Metropolitan Museum of Art, New York

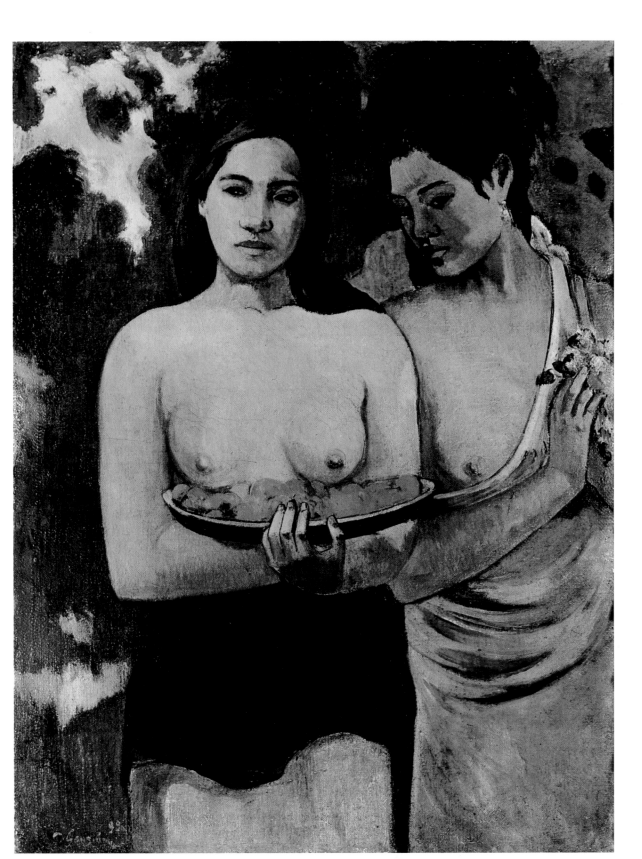

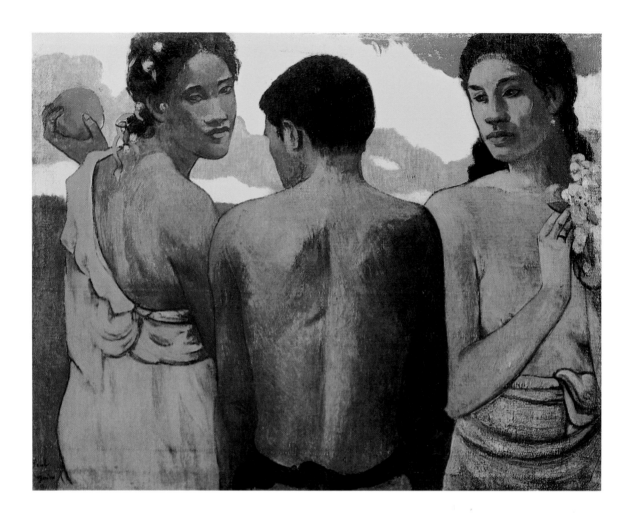

Three Tahitians, 1899
Oil on canvas, 73 × 94 cm
National Gallery of Scotland, Edinburgh

Gauguin a thousand francs. Of all his works, it was the most awkward and unsophisticated that had found a buyer. Gauguin's courage revived.

In the period following these critical months, the artist was calm and relaxed. Indeed, he seemed filled with a blessed tranquillity. As if nothing had happened, his art picked up the familiar motif of the dreamy paradise island again. *The White Horse* (p. 79) is an eloquent example. Painted when Gauguin was convalescing, it reiterates a view of the harmony between Man and Nature as a cure for despair and mortal fear. The animal in the foreground, free of reins, reaching its neck down to the water, communicates a sense of the animal instinctiveness that prevails on the island. Mankind lives in friendship with the beasts. In the background, people are seen riding animals; no lengthy breaking-in has been needed — Man and beast respect each other, and Nature is Man's partner, not his tool. Mutual pleasure in the world is the source of universal happiness. In the period following his breakdown, Gauguin resumed his quest for that state of innocence.

Help from overseas was at hand as well. With the painter's written authority, Monfreid had sold off all Gauguin's pictures for next to nothing. They were bought by the art dealer Ambroise Vollard. Later, Pablo Picasso was to immortalize him in one of his Cubist portraits, but in the closing years of the 19th century there were many who viewed him rather critically, thinking his rapid rise to eminence was due to a preference for good business over good art. And now, in November and December 1898, it was Vollard, of all people, who exhibited the Gauguins he had just acquired for a song. At first Gauguin was vexed. But then Vollard made him the offer he had been waiting longer than a decade for. He guaranteed the painter 2,400 francs a year plus the cost of his materials, and, over and above that, proposed to pay two'hundred francs for every painting and thirty for every drawing. Gauguin knew, of course, that a painter friend of his,

**And the Gold of Their Bodies
(Et l'or de leures corps), 1901**
Oil on canvas, 67 × 76 cm
Musée d'Orsay, Paris

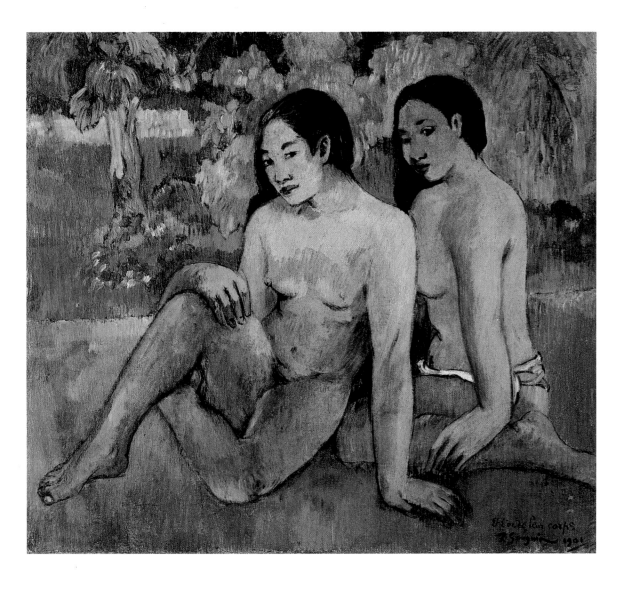

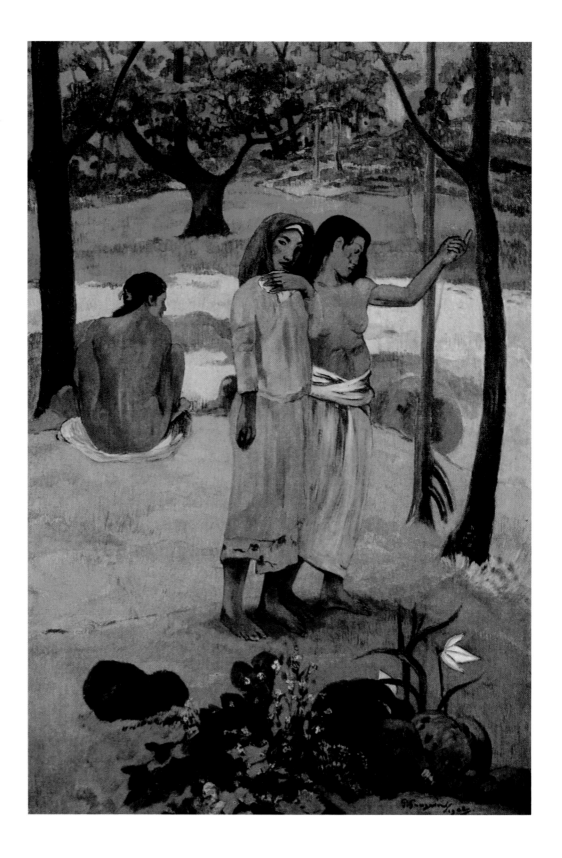

Maurice Denis, had an arrangement worth four times as much; but then, life on Tahiti was far cheaper. From now on, Gauguin would be able to lead a life free of financial cares. Would the door to his earthly paradise be opened at last?

Gauguin's new peace and self-possession increasingly made themselves felt in his choice of motifs. His *Two Tahitian Women with Mango Blossoms* (p. 81) have a monumental dignity of a classical kind. The two women are standing right in the foreground, perfectly naturally, not looking at us, as if they were alone. There is nothing artificial in their pose. They have not been positioned by Gauguin to match figures in art history, as was his habit in his nudes.

With its bright red fruit blossoms, which attract our attention, the picture remains discreet, and wholly devoid of grand gestures. The background setting is totally abstract. In dispensing with a backdrop of suggestive imagery, Gauguin helped his human figures (and the painting) to achieve a quality of charismatic timelessness.

The group of *Three Tahitians* (p. 82) makes the same impression of warm and honest intimacy. They too seem transfigured, and have an almost statuesque presence in this ambience of simplicity. They are neither talking to each other nor attempting to make contact with us; instead, they have a certain monumentality (against a background which is again abstract) — like monuments to the spirit of peaceable contentment. The massiveness of form and solidity of colour areas guarantee the work's rapt dignity. No details mar the vivid stature of the figures of detract from their lively physicality. These are not specific human bodies; these are not individuals; they are symbols of a life of peace and harmony. Gauguin was always out to portray that life; and to emphasize the individual, as European portraiture traditionally does, would not have fitted in with the replete naivety of the existence he was showing.

All in all, Gauguin should have been thriving on Tahiti. He enjoyed recognition and a friendly reception there, and his art was thought valuable and important. A native friend called Jotefa once spoke to him on the matter, and Gauguin recalled the conversation in these terms: "I believe Jotefa is the first person who has said that to me. They were the words of a savage or a child — you have to be one or the other to believe that an artist is performing a useful human task."

On Tahiti he was told what he had longed to hear back home: that art was useful, important, and relevant to everybody. He had travelled halfway round the world, far from *bourgeois* conceptions of art as a trivial pastime, in order to hear this confirmation of his mission, and of his very self.

And yet Gauguin seemed to have only a partial faith in Jotefa's statement, since he saw it as the opinion of a savage or a child. He continued to be divided and distrustful. While he saw the Tahitians as better human beings, he still valued their views less than those of his European contemporaries. If his savages were noble, they were second-class nobility.

His relaxed composure passed. He got entangled in countless legal battles. In the magazine *Les Guêpes,* which he published himself, he

Tahitian Woman, ca. 1900
Pastel, 56 × 49.6 cm
Brooklyn Museum, Brooklyn (N.Y.)

The Call, 1902
Oil on canvas, 130 × 90 cm
Cleveland Museum of Art, Cleveland

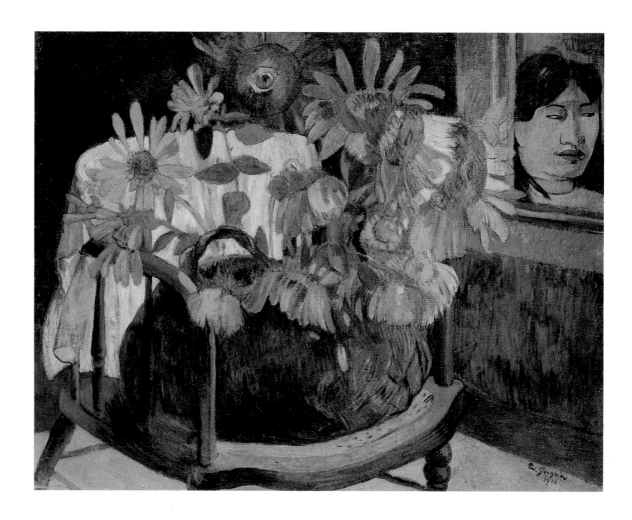

Sunflowers on a Chair, 1901
Oil on canvas, 72 × 91 cm
Hermitage, Leningrad

raged against colonialism, with all its incompetence and corruption, and was promptly inundated with libel suits. Doubtless he meant well in expressing solidarity with the island people, but his typically impetuous and rude outbursts showed that he remained unable to live at peace with himself. His finances were in good shape now, and his health was improving too, so he had to seek out the irritants without which he would have been bored. The magazine had no future, of course, but he promptly started another, called *Le Sourire,* and went on ranting at the colonial authorities, civilization, and indeed the entire world.

Gauguin portrayed the pleasant, amiable side of Tahiti — which had so far escaped the colonialists' clutches — in *Tahitian Idyll* (p. 87). It is the mixture as before — the vegetation, people, and rudimentary huts — but now there is a new dynamic quality in it all. The narrow, red path pours like lava into the foreground, the sense of movement emphasized by the riotous tree-trunks. The picture was to be a last avowal of faith in the island where he had sought an earthly elysium; but the closeness has become ambiguous and the quality of energetic

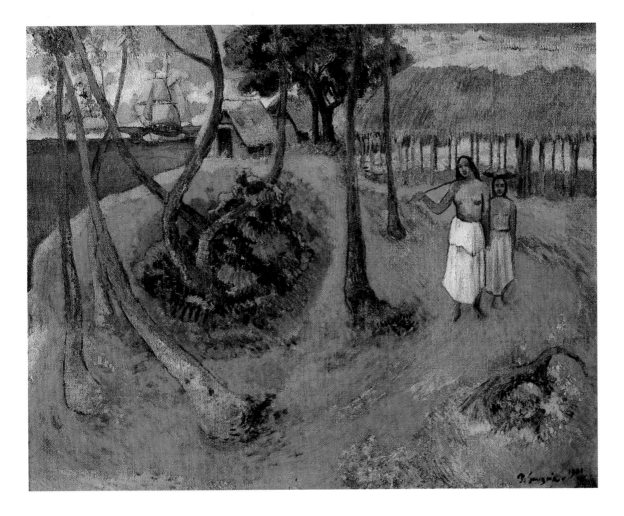

upheaval in the composition suggests change. And indeed there were changes in Gauguin's life, as he found himself obliged to look for another base in the tropics.

The immediate cause was the rumour of an epidemic in San Francisco. A good number of ships anchored in Tahiti to await developments before continuing to America. Instantly prices soared, and the cheap life which (in Gauguin's eyes) was one of the great advantages of the island was gone. In any case, he was beginning to feel that a change of scene was essential if his art was not to suffer: "My imagination began to flag on Tahiti, and in any case the public was growing too accustomed to Tahiti." Again he was confident: "My Brittany pictures seemed like rosewater after the Tahiti pictures. And once people see pictures from the Marquesas they'll think Tahiti was just eau de cologne."

On 10 September 1901 Paul Gauguin moved to Hiva Oa, the main island in the Marquesas, also a French colony. Gossip had it that his foremost reason for moving was the enforced chastity he was enduring on Tahiti, where the local women no longer found the grumbler

Tahitian Idyll, 1901
Oil on canvas, 74.5 × 94.5 cm
E. G. Bührle collection, Zurich

with his gammy leg so attractive. The Marquesas, at any rate, were not on the major shipping lanes and were thus less exposed to the dubious blessings of civilization, and Gauguin soon had a new lover, Marie-Rose Vaeoho by name.

He called his hut 'The House of Pleasure', and soon it was at the centre of a violent controversy. Gauguin had built his little house on land belonging to the Catholic church, but missionaries were as much of a thorn in his flesh as ever, and presently one of his own carvings graced the front garden. It was titled *Father Lecher and Sister St. Theresa.*

As usual, the artist got on best with the native population. Soon they were meeting at his home every evening, carousing and drinking. The church foresaw its flock being dispersed, and the bishop inter-vened, announcing a ban on visits to the artist. And once again Gau-guin was embroiled in legal battles.

The Rev. Vernier, who ran the Protestant school on the island, described him in this way: "He looked like a real Maori, with his colourful native-style loin-cloth and a genuine Tahitian shirt, his feet almost invariably bare, and on his head a green cloth student cap with a silver clasp at the side." And that was the appearance Gauguin presented in court when he faced charges of tax evasion. He refused to pay his taxes on the grounds that he was a savage. He hobbled into the courtroom on crutches, and had to be forcibly removed because he insisted on heckling: Gauguin the angry, anarchist ruffian, fighting for a better world.

The paintings of this period were poetic reminiscences of Arcadia. *Girl with a Fan* (p. 89) is a portrait of Tohotaua, wife of the Hiva Oa witch-doctor, and focusses on the expressiveness of her face. Gau-guin based the painting on a photograph, but in the transfer process he purified the image of the chance elements of reality. Again Gau-guin borrows from classical art; but this time the savage has the genuinely refined features and distinguishing marks of true civiliza-tion. Her body is lit from the top right, while her face is lit from below, as if by torchlight, in theatrical fashion. Though she is a beautiful woman, the corners of her mouth reveal a trace of bitterness, and in her eyes there is melancholy. Her position emphasizes these sugges-tions of insecurity: her chair appears to be tipping forwards into the depths that yawn this side of the picture's edge.

Two of Gauguin's last works examined riding as a metaphor of the close relationship between man and beast. In *The White Horse* Gau-guin had approached the subject circumspectly, presenting it in lusciously overgrown jungle, but in the two paintings titled *Horsemen on the Beach* (pp. 90 and 91) he chose a more open setting: the seashore. Both seashore scenes are given a touch of mystery by the two riders seen in profile, placed parallel to the base-line and obstructing the relaxed movement of the other riders. An unforced sensitivity to the harmony of the human and animal kingdoms takes on a more portentous dimension, and the vividness of these creatures is contained within limits which imply something that lies beyond. A note of discontent can be felt in the work. As in *Girl with a Fan,* dark

Girl with a Fan, 1902
Oil on canvas, 92 × 73 cm
Folkwang Museum, Essen

88

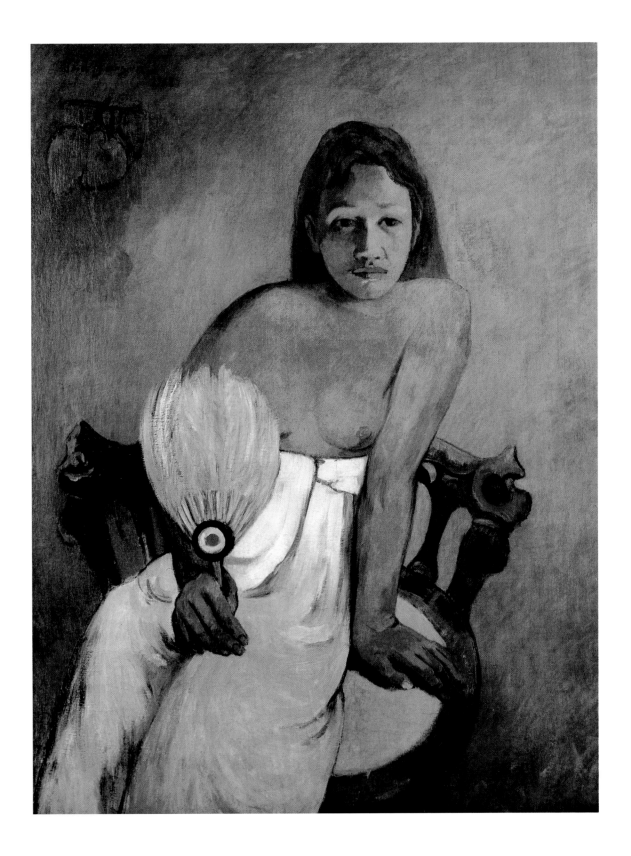

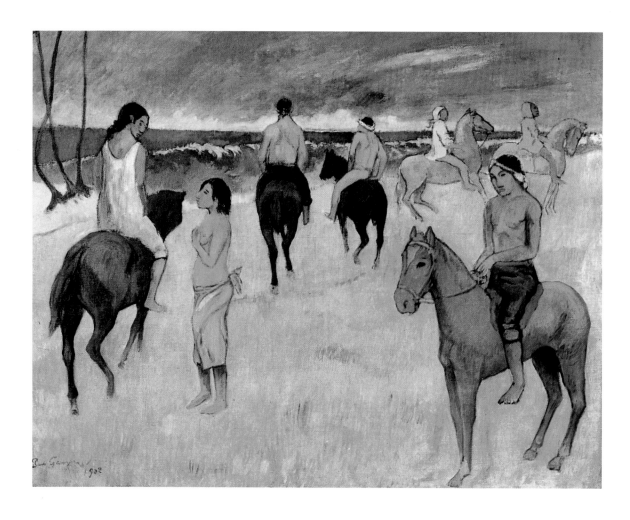

Horsemen on the Beach, 1902
Oil on canvas, 73 × 92 cm
Stavros Niarchos collection

premonitions can be sensed. And the friendly, relaxed ride along the beach somehow only serves to heighten those premonitions.

Barbarous Tales (p. 93) shows how much Gauguin's change of mood had infected his appreciation of the natural, naive world of the islands. The familiar motif of natives relaxing has been expanded to include the brooding figure of a European, one of Gauguin's Paris friends, the poet Meyer de Haan. He is interposed between the peaceful couple and the romantic jungle setting, and is seen contemplating the simple beauty of the two natives with all the ponderousness of the intellectual. And so we see Gauguin projecting into his poet friend his own awareness of the gap between himself and the people he admired. He had failed in his desire to become a savage. And it is this insight that makes Barbarous Tales his true testament, rather than Where Do We Come From? What Are We? Where Are We Going?, which pretends that all the differences between the cultures might be brushed aside by a pathetic appeal to spirit and life. Gauguin's whole heart was in his attempt to reconcile his love of the tropical world with the needs and wishes of the local people. He was a kind of inverted

missionary. He wanted to be converted by them. But in the last analysis he remained as much a prisoner of his own world as the missionaries who supposed that what was good for them was good for everybody.

The court's verdict in the tax evasion case was now known, and Gauguin was sentenced to three months' imprisonment and a fine of one thousand francs. "I shall have to lodge an appeal on Tahiti. The travel and lodging costs, and above all the lawyer's fee! How much will it come to? It will be the ruin of my finances and of my health. These troubles will be the end of me." Hateful society and its institutions did indeed manage to silence Gauguin. On 8 May 1903 Gauguin, the choleric anti-cleric, sent for a priest. He had had two attacks and wanted the church's final blessing. Soon afterwards he was dead. The priest reported that the natives could be heard wailing: "Gauguin is dead! We are lost!"

Horsemen on the Beach, 1902
Oil on canvas, 65.6 × 75.9 cm
Folkwang Museum, Essen

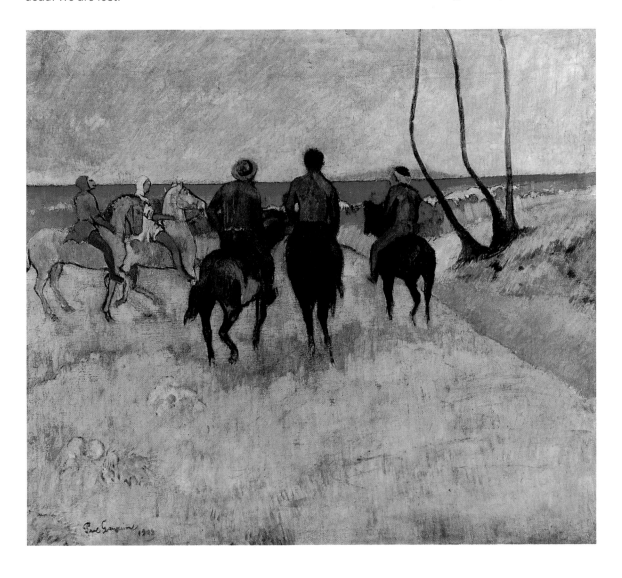

Barbarous Tales, 1902
Oil on canvas, 131.5 × 90.5 cm
Folkwang Museum, Essen

A few days earlier Gauguin had received another letter from Monfreid: "These days you are referred to as that exceptional, magnificent artist who sends in his bewildering but inimitable works from the middle of the Indian Ocean — the creation of a great man who, as it were, has departed this world. You enjoy the immunity of the great dead. You have entered the annals of art history." Gauguin was not to live to relish his triumph. Who can say what his reaction to the world's sudden applause would have been? It was still that hated, unbearable world which he forever wanted to escape. And yet it was in Gauguin and in his rejection of the world that civilization, complex as it is, discovered its own image.

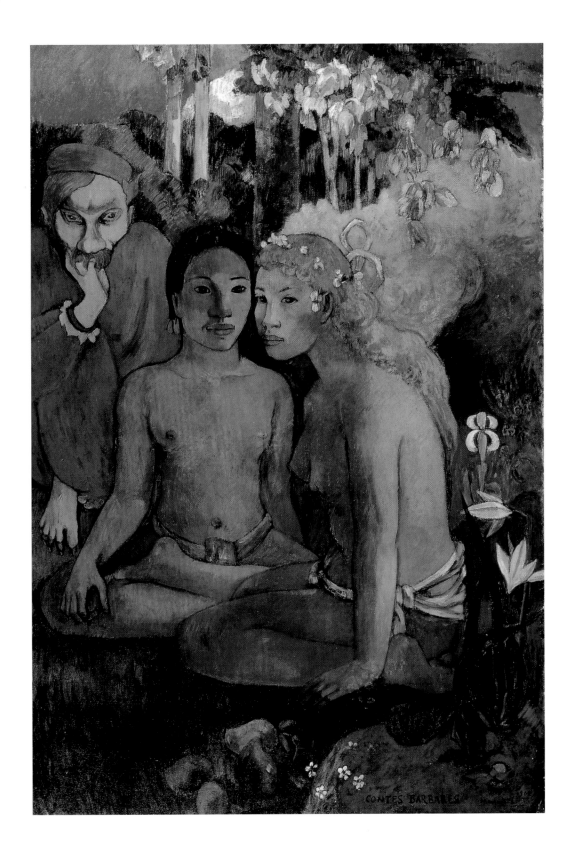

Paul Gauguin 1848–1903
A Chronology

1848 On 7 June Eugène Henri Paul Gauguin is born in Paris, the son of Clovis Gauguin, a Republican editor, and his wife Aline Marie Chazal.

1849 After Louis Napoléon comes to power, the family emigrate to Peru. Gauguin's father dies on the way. The mother and children stay with relatives in Lima.

1855 Return to Uncle Isidore's in Orléans.

1859 Paul goes to the *Petit Seminaire,* a boarding grammar school in Orléans, where he receives his schooling until 1865.

1862 Return to Paris.

1865 Paul goes to sea as a ship's boy on the Luzitano, voyaging between Le Havre and Rio de Janeiro.

1866 Thirteen-month voyage round the world as second lieutenant on the Chili. Death of his mother.

1868 Joins the navy.

1871 Able-bodied seaman aboard a corvette, the Jerôme Napoléon, during the Franco-Prussian War. After the war Gauguin works as a broker's agent at Bertin's in Paris, and meets Claude-Emile Schuffenecker. First drawings.

1872 Gauguin and Schuffenecker study painting and visit the Louvre together.

1873 22 November: Gauguin marries a Danish governess, Mette Sophie Gad.

1874 Visits Pissarro and meets other Impressionists, and collects their paintings. Studies painting at the Colarossi Academy. Son Emil born.

1876 Daughter Aline born. Exhibits at the *Salon* for the first time.

1879 Son Clovis born. Spends summer painting with Pissarro in Pontoise. His bank and stock exchange deals provide a comfortable income and he con-

tinues to buy paintings. Exhibits at the fourth Impressionist show.

1880 Rents a studio in the Vaugirard quarter. Exhibits with the Impressionists and the *Indépendents.*

1881 Painting with Pissarro and Cézanne. *Suzanne Sewing* (p. 6) is well received. Son Jean René born.

1882 Exhibits at the seventh Impressionist show.

1883 Quits his stock exchange job. Break with Cézanne. Spends the summer painting with Pissarro in Osny. Birth of fifth child, Pola.

1884 Moves to Rouen, but then in October financial straits force him to move to Mette's parents in Copenhagen. Unsuccessful attempt to be a sailcloth salesman.

1885 Exhibition in Copenhagen is a failure. Falls out with his in-laws and returns to Paris, taking Clovis. Mette stays in Denmark with the children.

Paul Gauguin: *Mette Gauguin in Evening Dress* (detail), 1884. Oil on canvas, 65 × 54 cm. Nasjonalgalleriet, Oslo

Paul Gauguin with his son Clovis and daughter Aline in Copenhagen, 1885

Gauguin in Paris in front of his painting *Brooding Woman* (**see p. 41**)**, around 1893/94**

Gauguin in 1888

Gauguin with his palette

1886 Working as a bill-poster. Puts Clovis in a *pension* and goes to Pont-Aven in Brittany, where he meets Bernard. Again in Paris he meets Theo and Vincent van Gogh, and Degas. Dreams of travelling to the tropics.

1887 Mette visits him in Paris. In April he and fellow-painter Laval travel to Panama and then Martinique. Both fall ill. Back in Paris he moves in with the Schuffeneckers. Theo van Gogh buys some pictures and ceramic works.

1888 February to October in Pont-Aven with Bernard, Laval and Meyer de Haan. Break with Impressionism. With Bernard he founds "synthetic Symbolism". Paints *Vision after the Sermon* (p. 21). Solo exhibition at Theo van Gogh's gallery. Late autumn with Vincent van Gogh in Arles. Following their misunderstandings he returns to the Schuffeneckers in Paris.

1889 Exhibits twelve paintings with *Les Vingt* in Brussels. Schuffenecker arranges a show at the Café Volpini. In Pont-Aven again, and Le Pouldu. Influences young painters such as Sérusier, Denis and Bonnard.

1890 In Paris until June. Plans to emigrate. Second stay in Le Pouldu. Acquaintance with the Café Voltaire Symbolists: Monfreid, Redon, Mallarmé. Organizes an auction of his paintings to finance his emigration.

1891 Sells thirty paintings at the Hôtel Drouot for 9,860 francs. Quarrel with Bernard. Bids farewell to his family in Copenhagen and friends in Paris and on 4 April takes ship to Tahiti, where he arrives on 28 June. Starts on his autobiographical *Noa Noa*.

1892 Serious illness. He is nevertheless productive and sends seven paintings to Paris.

1893 Eye disease, loneliness and financial distress oblige him to return to Paris early. Uncle Isidore's legacy alleviates his situation. Rents studio in Rue Vercingétorix. Living with Anna the Javanese (see p. 58).

1894 Farewell visit to Copenhagen. April to December with Anna in Brittany. Breaks his ankle in a brawl with sailors.

1895 Second, unsuccessful auction at the Hôtel Drouot. 3 April takes ship for Tahiti a second time.

1896 Builds himself a live-in studio at Punaania. Plagued by illness, depression and financial worries, but still paints numerous masterpieces.

1897 Aline dies. Definitive break with Mette. Serious illness: Gauguin's health has been ruined by alcohol and syphilis. *Noa Noa* published. Paints *Where Do We Come From? What Are We? Where Are We Going?* (pp. 76/77).

1898 Attempts suicide. Hospitalized in Papeete. Takes a job in Paofai until money arrives from Monfreid in Paris.

1899 Editing two satirical journals. His lover Pau'ura gives birth to a son, Emile.

1900 Vollard, a Parisian dealer, offers Gauguin a contract and buys pictures. Improvement in his financial position but again hospitalized. Son Clovis dies.

1901 In the autumn, sells his Tahiti house and moves to Atuana on the island of Dominique in the Marquesas. Builds his 'House of Pleasure' on Catholic mission land.

1902 Quarrels with the church and colonial administration in Atuana. Heart disease and syphilis set him longing for home. Monfreid advises against returning since it would destroy the myth of the South Seas painter.

1903 The refractory Gauguin is sentenced to three months in prison and fined 1,000 francs. He has neither the energy nor the money to defend himself. Before he can begin his sentence he dies on 8 May, aged 54, at his home in Atuana.

The author and publishers would like to thank the museums, collectors, photographers and archives who gave permission to reproduce material. Picture credits: Gruppo Editoriale Fabbri, Milan. André Held, Ecublens. Bildarchiv Alexander Koch, Munich. Walther & Walther Verlag, Alling.